THE PICKLE FAMILY CIRCUS

Terry Lorant

and

Jon Carroll

Chronicle Books, San Francisco

Printed in Japan

Library of Congress Cataloging-in-Publication Data

Lorant, Terry.
 The Pickle Family Circus.

 1. Pickle Family Circus—History. I. Carroll, Jon.
II. Title.
GV1821.P47L67 1986 791.3'092'2 85-25456
ISBN 0-87701-377-2

ISBN 0-87701-377-2

Produced by
The Pickle Family Circus Inc.,
San Francisco

Carroll & Terry Ltd., producers

Photography: Terry Lorant
Design: Michael Patrick Cronan,
Nancy Paynter, Michael Patrick
Cronan Design, Inc.

Chronicle Books
1 Hallidie Plaza
San Francisco, California 94102

SAN FRANCISCO'S
PICKLE
FAMILY
CIRCUS

400 Missouri Street
San Francisco, CA 94107

*For all of the love and support and cash and critical input that enabled this
book to happen, we would like to thank:*

*June Lorant, (thanks mom, for encouraging me to run away and join the
clowns!), Barbara Arnay, Rene & Judith Auberjonois, Roslyn Banish,
Jim Bauerlein, Peter Beren, S. Michael Bessie, Jon Boorstin, Ann Brebner,
John Brennan, Ken Coburn & Interprint, Laurie Cohen, Liza Cohen,
B. T. Collins, Sunny & Dana Comfort, Martha Diepenbrock, Alice Donald,
Bill Edwards, Karin Hibma, Don Hutter, Leni Isaacs, Bud Johns,
Tracy J. Johnston, Paul Leinberger, Martin Levin, Stefan Lorant,
Josh & Danny Meisler, Fred Mitchell, The Moid Family, Niura Monferrato,
Helen Parkman, Nancy Paynter, E. Gabe Perle, Michael Phillips,
Steve Pinsky, Mr. Ravelli, John & Suzanne Rogers, Jim & Carolyn Robertson,
Tim Savinar, John Read Serafini, Paty Silver, Paula Singer, Peter Solomon,
Grace Stoye, Fran Sutherland, Dick Warren, Tom Wolf, Baron Wolman,
Erika Zaccardo,*

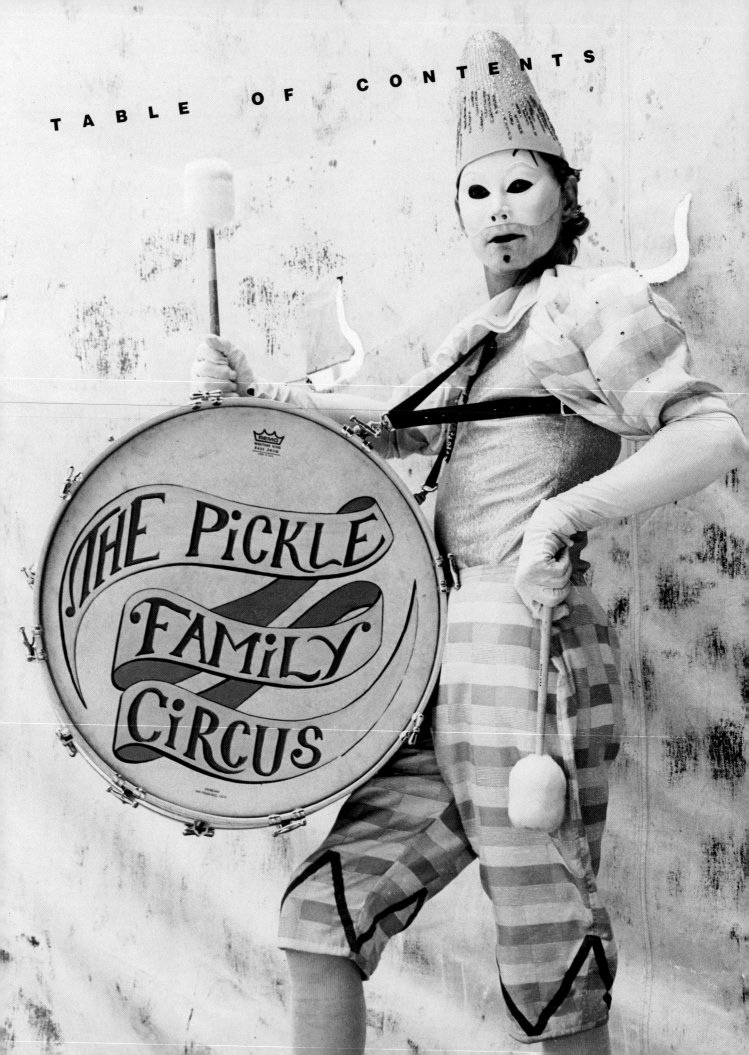

1 THE GREAT CHARIVARI

Charivari (n). A mock serenade with kettles, pans, horns and other noise-makers given for a newly married couple; hence, any large, noisy celebration. In circus parlance, the traditional opening act, with clowns clowning, tumblers tumbling, jugglers juggling, general madness and confusion. From the Late Latin *caribari*, headache.

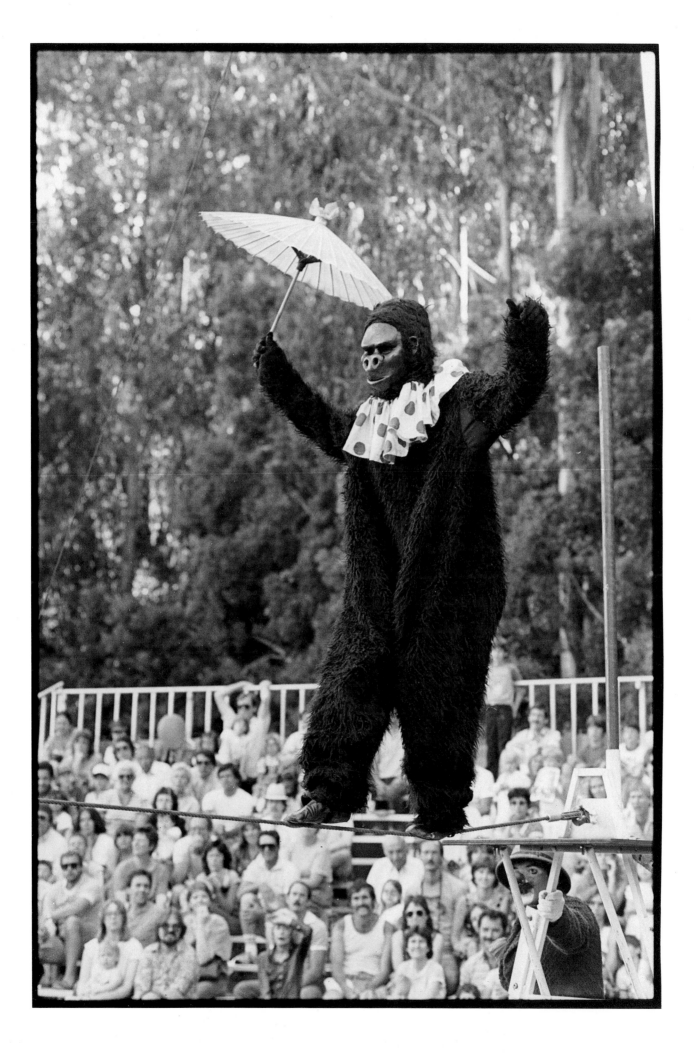

Geoff Hoyle

▶

(Bottom to top) Lorenzo and Lorenzo

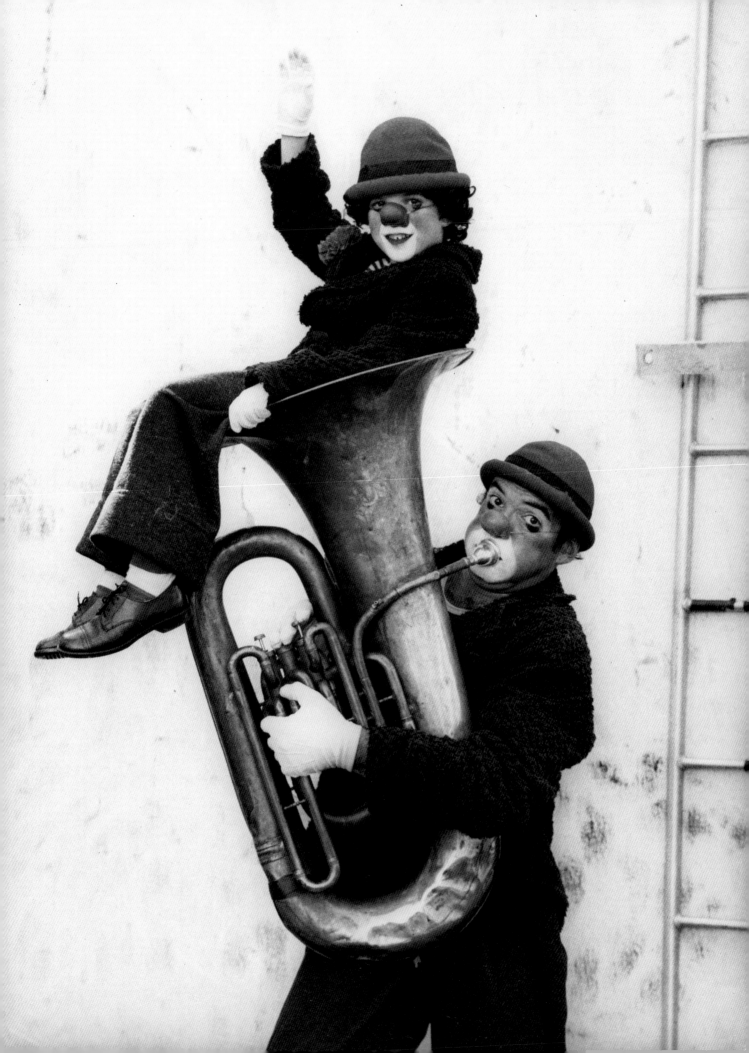

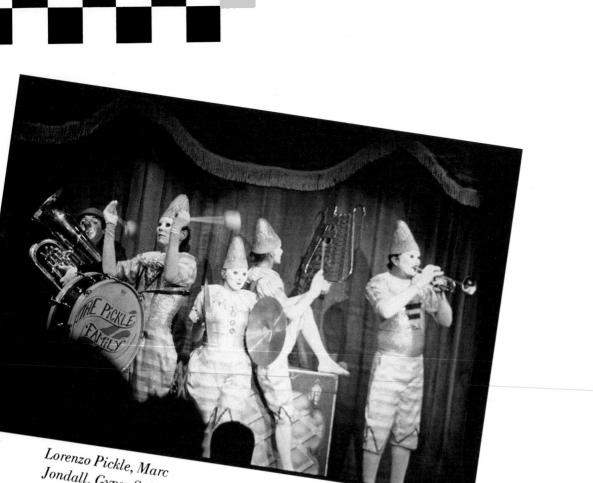

*Lorenzo Pickle, Marc
Jondall, Gypsy Snider,
Wendy Parkman,
Michael Moore*

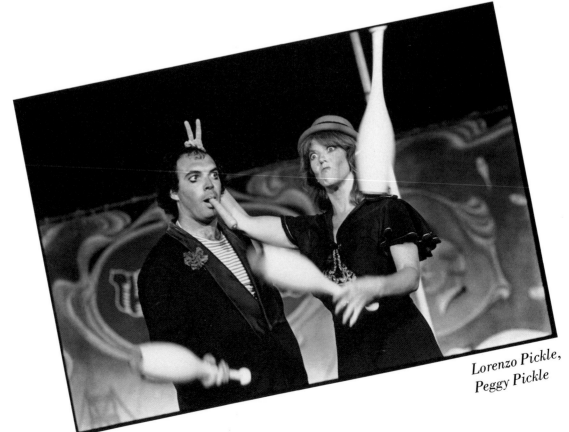

*Lorenzo Pickle,
Peggy Pickle*

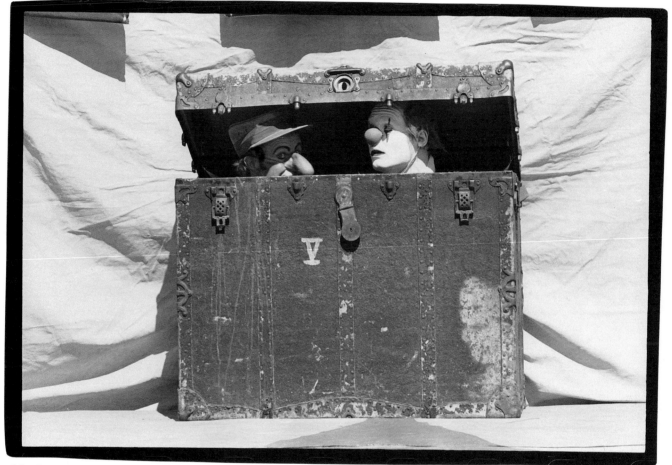

Mr. Sniff, Willy the Clown

The back of the trunk:
Doni McMillan fiddles
as Sniff and Willy
perform

▶

Wendy Parkman in
Washington Square,
San Francisco

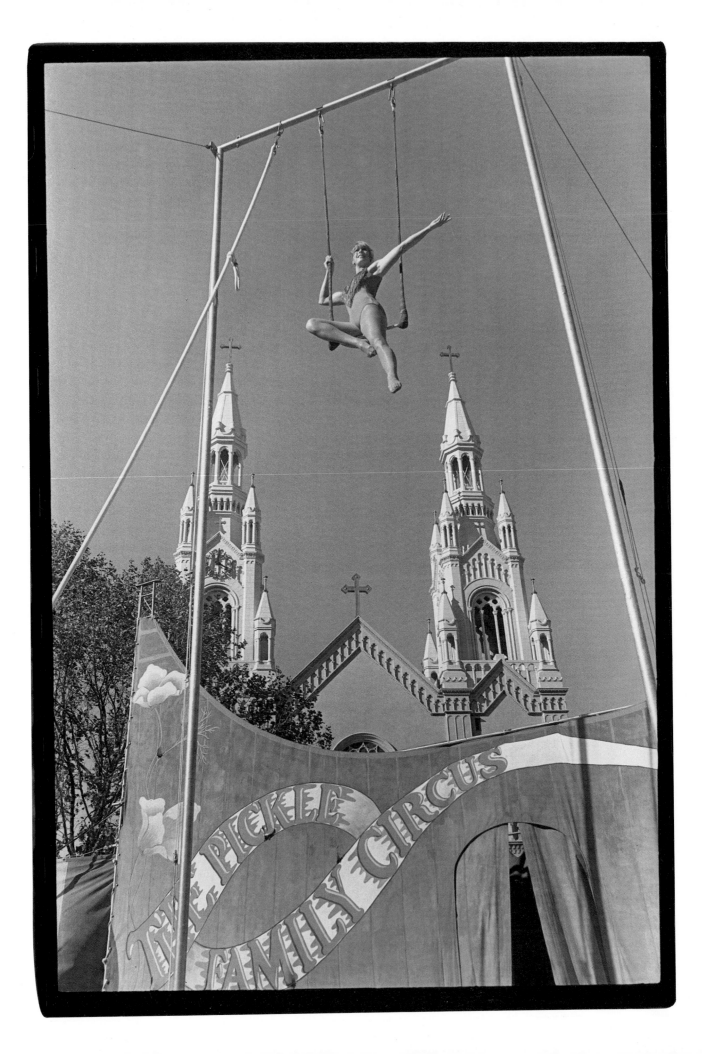

HELLO, EVERYBODY

A typical Pickle Family Circus production happens on a warm Saturday afternoon in a grassy park on the outskirts of a small Northern California coastal town. The crowd is small by urban standards but large by local standards—perhaps 1000 people. The air is hot and damp and a little smokey; the aroma of barbecued chicken and freshly popped corn mingles with the sharp tang of the soft salt breeze.

The path to the Circus arena is flanked by a midway organized and staffed by the civic-minded in the community. There are hundreds of children, many with gaudy red stars on their cheeks or dramatic lightning bolts streaking across their foreheads; the face-painting concession always does good business. There are parents clutching babies or holding balloons, smiling benignly and looking for a place to sit down. There are senior citizens in twos and threes, ambling, chatting, smiling, remembering. There are teenagers looking for other teenagers, their body language indicating that they are perhaps a bit too sophisticated for this form of children's entertainment.

There are booths with standard midway games: balloon-popping, ring-tossing, bean-bag-throwing, hurling-the-wet-sponge-at-the-local-authority-figure. There are stands purveying hot dogs and hamburgers, pork shish kabob and barbecued chicken, soft drinks and beer, watermelon slices and oversized cookies. There are card tables set up to dispense brochures, buttons and bumper stickers advocating worthy causes.

Gradually, as showtime nears, a line forms outside the entrance tent. The buzz of anticipation grows and thickens. Music is dimly heard drifting over the high canvas sidewalls. Suddenly, a flap lifts, and the swaying ribbon of people moves inside. Adults gravitate toward the bleacher seating; the younger kids, particularly those who had been to the Circus before, sit on the grass surrounding the 26-foot ring, nestling as close as possible to the red and yellow ring curb. Behind the ring is a brightly painted backdrop with the name "Pickle Family Circus" rendered in modified Art Nouveau script. To the right of the backdrop, the band is already in full swing, playing something uptempo and celebratory. The saxophone player is large and bearded; this is a rule.

Then, a fanfare. The stage explodes with action: people doing back flips, people juggling balls, people running around carrying flags, people leaping over other people; people dressed in spangles, in tights, in animal costumes; general confusion and madness and flash and beauty; something between a Cossack dance and a fire drill.

Ladies and gentlemen, the Pickle Family Circus.

In the subsequent two hours, events of great color and diversity occur. Smiling people throw a remarkable number of objects to one another very

rapidly. Someone in a gorilla costume cavorts. A young woman sails above the ring on a trapeze. Three people bounce and twist on a trampoline. A person in a funny costume emerges from a trunk. Tight and slack wires are walked. There is a speech of welcome, an intermission, and a speech of thanks. A balloon the size of a potting shed is thrown from the ring into the crowd, where it bounces around for many minutes. Members of the audience say oooh and ah. Clowns fall down and get up again.

At the very end of the show comes the Big Juggle, during which every cast member (except for a band member or two) participates in a club-passing routine rather more intricate than the human eye can comprehend.

Then there is applause.

The Just Desserts booth on the midway at Fort Mason, San Francisco

The Pickle Family Circus began in 1974, in a city (San Francisco) and at a time in which it was considered important, even necessary, to create a satisfying unity between work and art and politics. The precise dynamics of that ideal were often unclear, but they went something like this: It was meaningless to denounce exploitation as a citizen if you participated in it as a salaried worker. It was meaningless to advocate and develop aesthetic ideals if the art you practiced was cynical and compromised. It was meaningless to make art that did not advance your political ideals.

It was the great wheel of West Coast radicalism. There were quarrels over tactics, disputes over how didactic the politics should be, arguments about what constituted worthy art, but the first principle was agreed upon: the compartmentalization and implicit self-deceit of American life was destructive. It was everyone's duty to expose contradictions and demonstrate alternatives.

Peggy Snider and Larry Pisoni, the founding members (along with Cecil MacKinnon) of the Pickle Family Jugglers, the precursor of the Pickle Family Circus, had both worked with the San Francisco Mime Troupe. The Mime Troupe was a seminal organization: a gritty, angry guerilla theater that was nevertheless funny, accessible and skillful.

A notion of sythesis began to occur. Why not combine the structure and politics of the Mime Troupe with traditional circus acts? A sort of gorilla theater, as more than one person has remarked. Call it the Pickle Family Circus.

The implications were immediate and obvious. A redefined circus meant no scantily clad chorines dangling from long ropes. It meant no animal acts; putting a creature in a cage and taking it on the road is obviously cruel and unusual behavior. It meant no artificial division of labor, with low-paid roustabouts endlessly toiling so the stars could sweep in and garner assorted kudos. It meant an organizational structure that was, if not precisely a collective, at least a vigorous democracy.

It meant that money should not be the overwhelming concern: no packing it in when the times got tough and money got scarce; the ideal deserved tenacity and courage. Likewise, it postulated a certain perfectionism and a well-developed, constantly improving set of professional standards. Cynicism about performance leads to cynicism about the audience, which defeats the whole purpose.

And it meant interaction with the community, particularly those members of the community who were deemed demographically undesirable by other traveling troupes, undesirable because they were too old or too young, undesirable because they lived in the wrong place or didn't make enough money. It meant working with other non-profit organizations so that much of

Ecstasy and agony: Wendy Parkman and Lorenzo Pickle

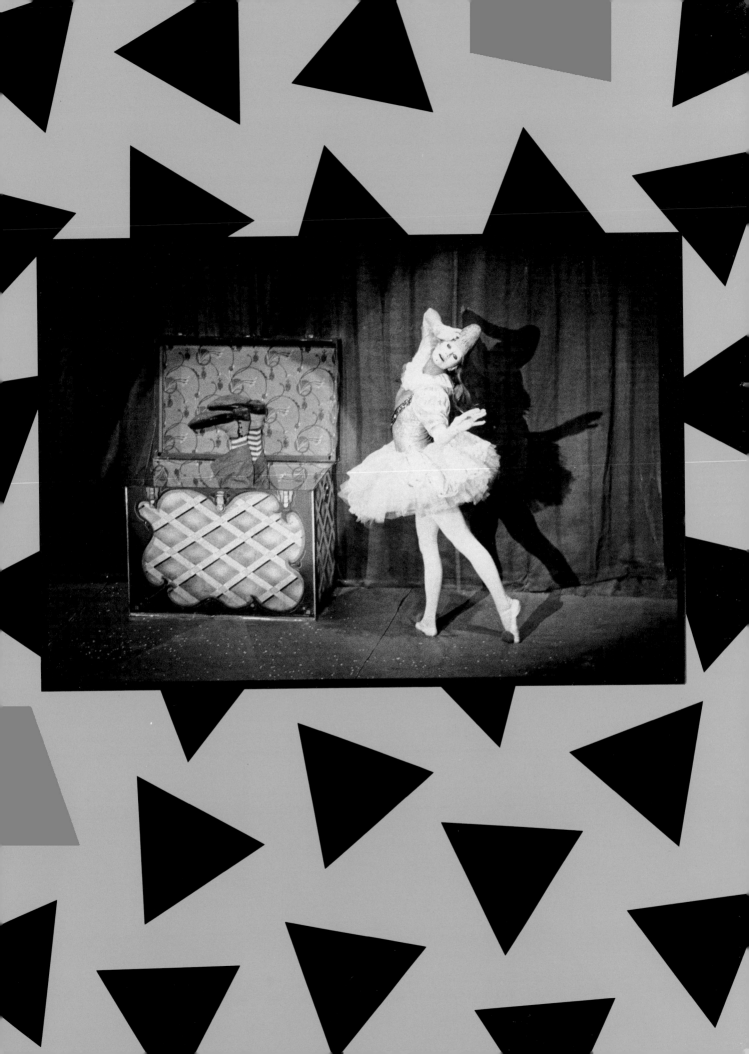

the money generated would remain in the community to support the people who needed it most. It meant traveling to small towns and seeking out people who had never before considered sponsoring, or even attending, a circus.

The Pickles started small. The first show, in a run-down gymnasium at John O'Connell School in San Francisco's Mission district, opened in May of 1975. The Circus didn't go on the road until 1976, when the first grant from the National Endowment for the Arts enabled it to tour five towns in Northern California. The next year, a few towns in Oregon were added to the roster, then Washington, then Nevada and Arizona. By the fall of 1984, the Pickle Sphere of Influence extended from San Diego on the south to Seattle on the north.

There were a few one-time-only adventures along the way. There was a trip to Alaska in 1979, fraught with tribulation and joy. There was a six-week stint at the Round House in London during Christmas of 1981. Earlier in 1981, there had been a Pickle-produced theatrical show called Three High featuring Larry Pisoni, Geoff Hoyle and Bill Irwin, at the Marine's Memorial Theater in San Francisco.

Many people ask: Where did the name Pickle Family Circus come from? The following are possible answers: (a) Cleveland, (b) the old vaudeville notion that "p" and "k" are the funniest letters in the alphabet, (c) an imprecise but noticeable similarity between the words "Pisoni" and "Pickle", (d) a jar of Kosher dills, or (e) there are some things, doctor, that man is not meant to know.

A few words about this book: Terry Lorant has been taking photographs of the Pickle Family Circus almost since the beginning. Ostensibly, these photographs were for publicity purposes, but there were higher ambitions lurking about: documentation and art, not necessarily in that order.

Sometime in 1983, as the PFC 10th Anniversary loomed on the horizon, the idea of doing a Pickle Family Circus book occurred to several people simultaneously. Terry began tape-recording interviews with Pickles past and present. The idea was to create a sort of oral history of the first 10 years to complement the photographs. It was impossible to interview everyone—at last count there were just over 100 people who had performed or traveled with the PFC. The selections were made on the basis of (a) longevity, (b) geographical availability, and (c) willingness to answer tedious and repetitive questions. To further pare down the sample, it was decided to interview only those people who had been with the PFC before June of 1984. This is a book about the first 10 years; Volume II (*The Pickle Family Circus: Years of Greatness, Times of Glory*), to be published in the fall of 1995, will continue the story.

The names of all the interviewees, together with a few tidbits of biographical information, appear at the end of this chapter, on pages 26 & 27. When you need context, that's the place to get it. The complete list of all Pickles past and present can be found on pages 148 & 149.

On an even more personal note: I came to this project very late, long after most of the interviews were completed. I had seen the PFC precisely once in my life before getting involved with this book; my fund of information about them was scanty, occasionally inaccurate. The dynamics of my involvement, I was later to learn, were classic PFC: First I was just going to make suggestions, then I was just going to write the introduction; I ended up selecting and organizing the quotes, doing a fair number of supplemental

interviews, writing the connective material, brooding endlessly about the project. Sort of sucks you in, it does.

So this book is, by no stretch of the imagination, a journalistic endeavor. Various members of the PFC read the manuscript and suggested changes; the final product is the result of spirited discussion, not individual inspiration.

Nevertheless, I get to say what I think. I've spent over a year now hanging out with the Pickle people, asking questions about juggling and tuba-playing and grant proposals and clown makeup and the history of the trapeze. I've had conversations that didn't have the remotest relevance to the book; vile curiosity, merely. The more I knew, the more I wanted to know.

So I think a couple of things.

Thing one: The Pickles are a marvelously chaotic organization. In some ways (the image is irresistible) the whole enterprise reminds me of a fat clown. Lots of running around and yelling and falling down; lots of strange objects of uncertain function hanging from comical appendages. Sometimes you wonder how the whole unwieldly organism will ever make it across the stage.

And yet, underneath, it's all sinew and bone and skill. The skeleton is lean and functional; the brain is constantly working. It couldn't do what it does if it didn't know what it was doing. There's some competence involved in running a tight, well-controlled, hierarchical organization; but the real skill comes in creating a loose, loud-mouth, democratic organization that works without all the solaces of rigid structure.

Thing two: Consider the hypothetical but essentially real scene postulated at the beginning of this introduction. I left one thing out: the skill of the performers. The Pickle Family clowns are almost certainly the best American clowns of their generation; the club passing routines are as good as you'll find anywhere; the acrobatics and trapeze routines are polished and careful and lovely.

And it ain't on television, or in some cavernous convention center. It's right there, the best there is, performing for you and your friends, supporting your local day care center or senior citizens facility or charitable enterprise.

It's a gift, is what it is. It reintroduces the notion of human scale to performance; it reaffirms the links between social involvement and show business.

Six months ago, a bunch of Pickles were kicking around possible titles for this book. One suggestion, borrowed from a phrase that had become a sort of Pickle aphorism, in itself a reworking of a familiar American idea, was: "The Circus Ran Away With Us All."

I didn't understand it then. Now I do.

— Jon Carroll
September, 1985

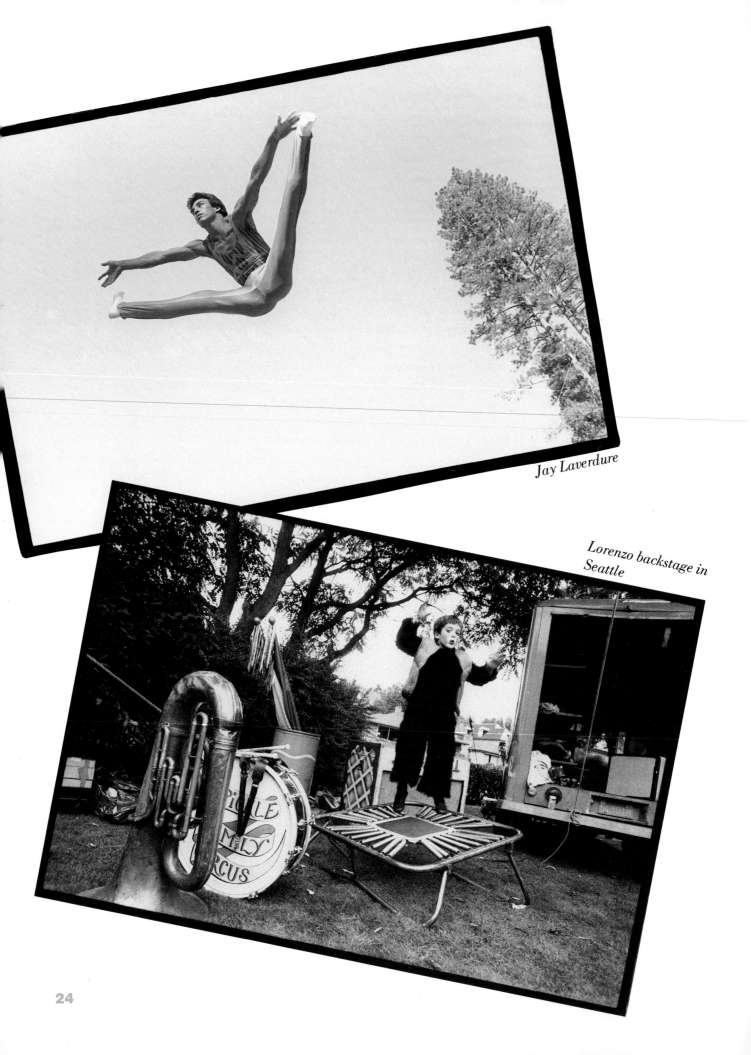

Jay Laverdure

Lorenzo backstage in
Seattle

24

Michael Ohta

Robert Burkhardt Jr. (a/k/a Bad Bob) Born in Cornwall, NY. B.A. Princeton 1962. Peace Corps in Iran, 1962-64. M.A. Columbia 1968. Ph.D. Union Grad. School 1971. Plumber 1972-76. Conservation work since then. Touring member of PFC 1976-84. Roustabout, juggler, trumpet player, barker.

Sando Counts Born in San Diego. B.A. in Performing Arts from Antioch College/West, 1974. Performed at the Dicken's Faire in San Francisco and the Rennaisance Faires in Novato and Los Angeles. PFC 1977-80, wire walker and acrobat. Currently living in San Francisco performing, writing and working with Theater Artaud.

Randy Craig Born in Washington D.C. B.A. in Theater Arts from Pomona College, 1968. Worked as an actor and musician with the San Francisco Mime Troupe. PFC 1975-81 as piano player, composer, truck driver and juggler. Currently lives in San Diego; writes scores for theater, movies and TV documentaries.

Sara Felder Born in Brooklyn. B.A. in History from U.C. Berkeley, 1982. Joined PFC as an apprentice in 1983. Juggler, roustabout, club swinger.

Judy Finelli Born in New York City. B.F.A. from N.Y.U. Juggler, clown, actress, circus historian and critic. Past president of the International Jugglers Association. Worked with Hovey Burgess on "Circus Techniques", published in 1976. Touring member of PFC 1982-83. Currently co-director of the PFC School.

Jeffrey Gaeto Born in Chicago. Moved to Michigan and then to Florida. Performed in a Top 40 soul band while still in high school. Studied composition and arranging through the Berkelee School of Music. Joined PFC 1982. Piano player, composer, truck driver and juggler.

Geoff Hoyle Born in Hull, England. B.A. in English and Drama from Birmingham University. Studied with Ecole de Mime Etienne Decroux. PFC 1975-81. Clown, mime, actor, Mr. Sniff. Currently lives in San Francisco; works solo and with ex-Pickle Keith Terry. Father of Pickle kid Jonah Hoyle.

Bill Irwin Born in Santa Monica, CA. B.A. Oberlin College, 1973. PFC 1975-80. Willy the Clown. Guggenheim Fellowship, 1984. MacArthur Award, 1984. Currently living and performing in New York.

Marc Jondall Born in Minnesota. Has held jobs as cab driver, phone solicitor, postman, auto factory worker, professional baseball player, bartender, baker, house painter, Santa Claus and trained bear. Joined PFC in 1981. Juggler, wire walker and clown.

Billy Kessler Born in New York City. Graduated Bronx H.S. Science 1967. Performed 1973-74 with Circo America Internacional in Honduras and Circo Pirrin in Guatemala City. PFC 1979-82. Juggler, acrobat, trampolinist and truck driver. Currently working toward a Ph.D. at the University of Washington School of Oceanography.

Zoë Leader Born in Los Angeles. Helped launch San Francisco's Community Garden Program in 1971. Co-directed the San Francisco Art Commission's Print and Design Dept. 1972-75. PFC 1975-84. Business manager, publicist, graphic designer, juggler and roustabout.

Terry Lorant Born in Dayton, Ohio. B.A. Antioch College 1973. Worked as co-developer of the education programs at San Francisco's Exploratorium 1972-77. Started shooting photos for PFC in 1975. Juggler, booker, photographer, road manager, roustabout.

Cecil MacKinnon Born in Chicago. M.F.A. from N.Y.U. Worked in New York Off Broadway, Off Off Broadway and at ACT in San Francisco, Shakespeare & Co. in Massachusetts. Co-founded the Pickle Family Jugglers with Peggy Snider and Larry Pisoni. Touring member PFC 1976-79. Juggler, acrobat, actress. Mother of Lily Marsh.

Michael Margulis Born in New York City. B.A. Oberlin College; M.A. Manhattan School of Music. Worked with the Peace Corps in Bolivia; played with the Bolivian National Symphony. PFC 1975-80. Trumpet and French horn player, composer. Father of Jesse Margulis Olsen.

Phil Marsh Born in McCook, Nebraska. B.A. U.C. Berkeley 1967. Founding member of Energy Crisis and the Cleanliness & Godliness Skiffle Band. Performed with Country Joe MacDonald. Currently living in New York teaching at Empire State College, and making a record of his childrens' songs. Father of Melinda and Lily Marsh.

Don McMillian Born in New York City. With Pickles 1975-78. Dropped out to get A.A. in Civil Engineering from San Francisco City College. Returned to PFC 1980-84. Roustabout, truck driver, business manager, production stage manager. Currently working as a stage manager in San Francisco.

Michael Moore Born in San Francisco. Worked 16 years as a freelance musician. Also baker and pizza maker. Has played in big bands with Sarah Vaughn and Dizzy Gillespie. PFC 1981-83. Trumpet and flugelhorn. Currently playing his trumpet in San Francisco.

Michael Nolan Born in Brooklyn, NY. B.A. Political Science, Columbia University, 1963. Worked for CBS News and Trust for Public Land. PFC 1975-77. Publicist and fundraiser. Currently works in San Francisco and promotes worthy causes.

Michael Ohta Born in San Francisco. Has worked as a carpet layer, bartender, utility repairman. Co-founder, People's Food System. Member, Board of Directors, Potrero Hill Neighborhood House. Joined PFC in 1979. Technical coordinator, truck driver, roustabout and juggler.

Kimi Okada Born in Cleveland, Ohio. Grew up in Minnesota. B.A. Oberlin College 1973. Founding member of ODC/San Francisco. First tap-dancing gorilla in the PFC. Has callaborated, choreographed and performed with Bill Irwin, Geoff Hoyle, Camden Richman and Robin Williams, and is the recipient of several NEA choreography fellowships.

Wendy Parkman Born in Boston. Sarah Lawrence College, 1967-69. Touring member of PFC 1979-83. Trapeze artist, dancer, acrobat and juggler. Worked with the Flying Karamazov Brothers in Chicago, 1983 and Los Angeles at the Olympic Arts Festival in 1984. Currently co-director of the PFC School.

Rebecca Perez Born in San Francisco. Worked as a teacher's aide for mentally handicapped pre-schoolers. Joined PFC in 1981 as trampolinist. Added trapeze, juggling and acrobatics to her roster of skills.

Larry Pisoni Born in New York City. Studied circus techniques with Hovey Burgess and Judy Finelli while working at the Electric Circus in New York. Moved to San Francisco in 1970 with plans to form his own troupe of performers. Worked as teacher and performer with San Francisco Mime Troupe 1971-74. Co-founded PFC in 1974. Artistic director, juggler, clown (Lorenzo Pickle), acrobat, wirewalker, tuba player and truck driver. Father of Pickle Kid, Lorenzo Pisoni.

Harvey Robb Born in Dayton, Ohio. Grew up in Detroit. B.A. Philosophy, University of Michigan; M.A. in Humanities, Wayne State University. Musician and performer San Francisco Mime Troupe. Plays saxophone and clarinet. Only human to have performed in every PFC show since the beginning of time.

Nick Saumé Born in New York City. Studied drums with John Cresci Jr. and Sam Ulano. Studied percussion in South America 1972-73. Has played with Marc Christopher, Sam the Sham and the Pharoahs, The Tymes and Harry Belafonte. PFC 1975-79 and 1982-83. Currently playing jazz around the Bay Area and learning cabinet making.

Gypsy Snider Born in San Francisco. Started PFC performances at the age of six in 1976. Juggler, acrobat, clown, roustabout. Attends the Urban School in San Francisco. Wants to be an actress when she grows up.

Peggy Snider Born in New York City. B.A. Bennington College 1965. Worked with San Francisco Mime Troupe 1968-76. Co-founder PFC 1974. Juggler, technical director, costume designer, company manager. Mother of Gypsy Snider and Lorenzo Pisoni.

Joanne Sonn Born in Chicago. B.A. University of Chicago. Moved to London when it was swinging to a halt; worked for Penguin Books and the Burlington Magazine. PFC 1978-84. Business manager, booker and fundraiser.

Keith Terry Born in Waxahachie, Texas. Founding member of the JazzTap Ensemble. Has played with Freddie Hubbard, Tex Williams and Honi Coles. PFC 1979-81. Drummer, percussionist and composer. Currently performs solo and with ex-Pickle Geoff Hoyle.

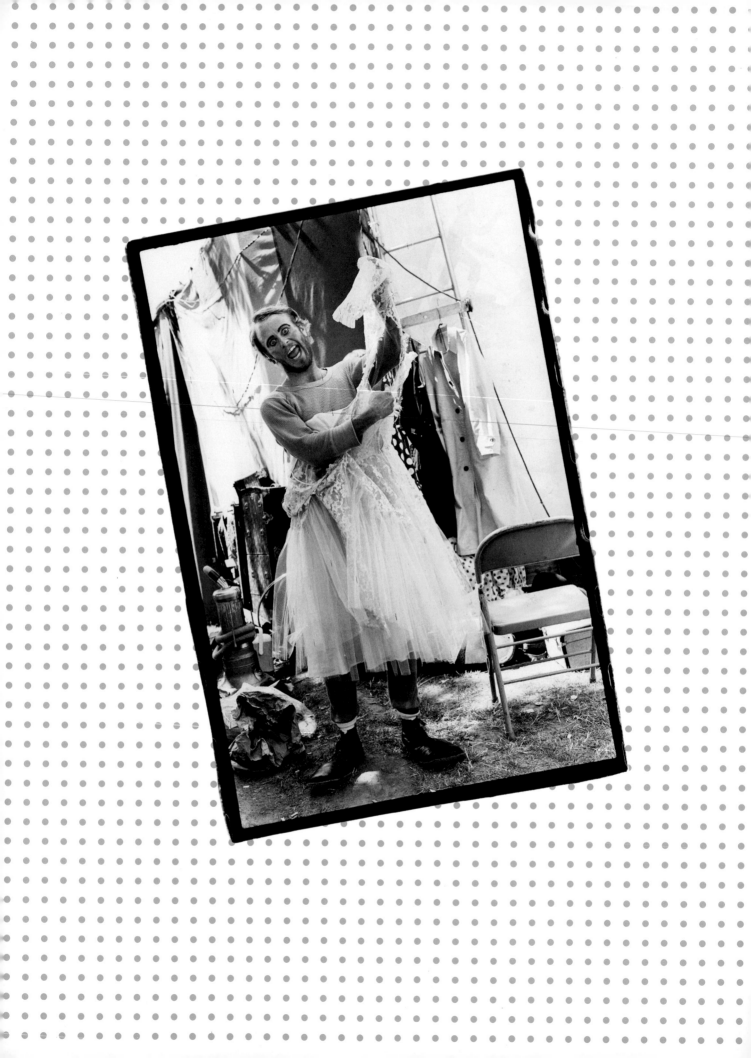

TRANSFORMATIONS

Things are not as they appear, here at the Circus. A young American male can wear bulky clothing and paint his face and become a jester, a clown, a holy fool, a prophet with a lineage as old as European civilization. A young American female can put on tights and spangles and become a wandering minstrel, a queen of the May, a link with the Middle Ages.

Historical ontogeny in funny shoes.

And not just people: places, things. A simple city park can become an arena, a theater of possibilities. A small town can become a celebration. A piece of canvas can become a painting; two chairs can become a room; two ropes and a metal bar can become a metaphor for aspiration. The commonplace becomes extraordinary; the extraordinary becomes usual. The more you look, the more you see.

And the more you listen, the more you hear.

"I think a lot of it has to do with transformation. I think that's something you don't see in another circus. You might see the tight-wire guy up there in costume, and you see him go from the ground to the wire, but that's the maximum in transformation. The audience sees us in the opening and we're very much closer to their reality, and then they get to see us do all these different things. It's the same thing for the sponsors who have seen us the previous day, or for any audience member who goes out to play Frisbee and hang around the park on a regular basis—first we're ordinary people, then we're not; yesterday it was an ordinary place, today it's a locus of mystery. Also there's the traveling thing; we sort of appear and disappear, like magic." — *Robert Burkhardt*

"I've always maintained that the best part of theater doesn't happen until the audiences are at home. After the performance is over, when there's discussion about it, or reflection about it, or even just a fleeting recurrence—that's the best part. It worked. People are changed; a little part of the Circus has stayed in their heads." — *Larry Pisoni*

Transformation; the essential interchange of art. The idea permeates all aspects of the Circus. Professional transformation, for instance:

"There was one major change for me. I remember when I was in Top 40 bands, it was so depressing. It was just survival. I can remember putting out weird combinations of sounds just to say 'screw you' to the audience. It was a real no-win situation, and I hated every minute of it. But when I play with the Circus, play the kind

of music I want to play, and I see that people are appreciating it, I feel, for the first time in my career, a rewarding mutual exchange."
— *Jeffrey Gaeto*

"Suppose you have a background in costume design, as I did, and you come to the PFC, and all of a sudden you have to make a two-person dog. Well, what does what you've learned have to do with that? Costumes are important to the Pickles in a whole different way—because we don't use theatrical lighting outdoors, we have to use costumes to visually indicate the change of mood from scene to scene. In a sense it's another transformation—costume design turns into lighting."
— *Peggy Snider*

Or transformation of relationships, people who would never have met in any other context discovering each other and helping each other, which in turn transforms various expectations about city folks and country folks and the nature of community.

"You can actually look at audience people or sponsors and say, 'You like this? Well, it's happening because you brought us here. That ticket you bought means we can come back next year.' That's really significant. Our Cottage Grove sponsors wrote and told us that, because of the Circus, they were able to keep their school open for another year. We got them over the hump. And then there are places like Arcata, where I would go back every year and talk to Barbara, who is a sponsor there, and she would talk not only about her organization, but about how the cycles of her life revolve around the Circus coming to town."
— *Zoë Leader*

"It was great driving into town and seeing people's faces as the truck pulled in, a real old-time thrill. I never wanted to come into town anonymously in a car; the truck, even the crappy old yellow truck, had class. I even loved unpacking it. You know, there would be Randy and Bad Bob and Larry and me, people I would never have been close to in any other context, forming this chain to pass out the bleacher steel, in that close space with the dark and the sweat and the infernal noise of steel against steel. I loved it!"
— *Billy Kessler*

Or transformation beyond definition, into magic, the ideal realm of the circus:

"I remember, in Ukiah one year, a little girl came into the ring as we were doing the closing statements, just walked right in and went up to Rebecca. She yanked a little ring off her finger and stared up at Rebecca and then she gave her the ring. And then she walked over to Little Lorenzo and took another ring off her finger and gave it to him. And I realized that the little girl saw Rebecca as what she wanted to be; and she saw Lorenzo as what she is right now! The joy of the ideal; the joy of the obtainable. I couldn't talk after that. I had the next line, and I couldn't say it; Peggy had to say it for me."
— *Marc Jondall*

"I remember the year we did the *élégante* act, and I sort of wafted into the ring as this white-faced fantasy dancer, and a little girl reached out and caught my hand and looked up at me and said, 'I'm a fairy princess too!'"
— *Wendy Parkman*

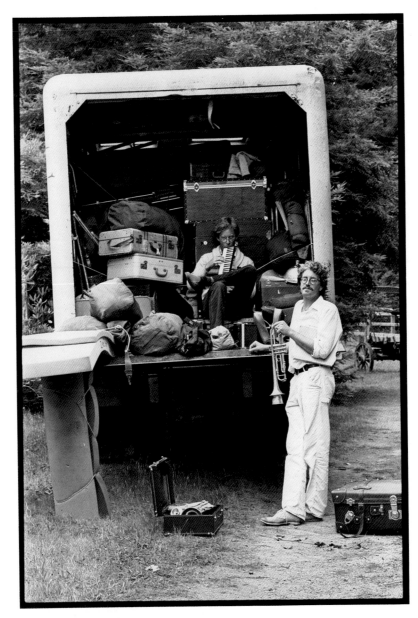

Bill Belasco and
Michael Moore;
Fort Bragg, California

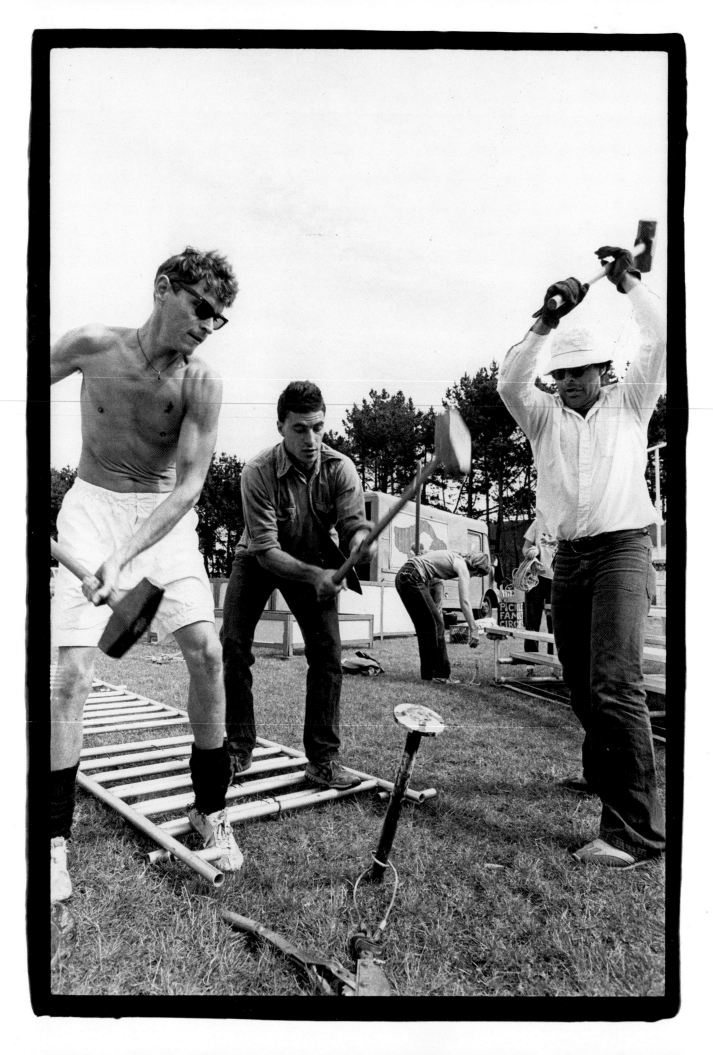

Marc Jondall, Carlos Uribe and Larry Pisoni drive stakes in Bend, Oregon
◀

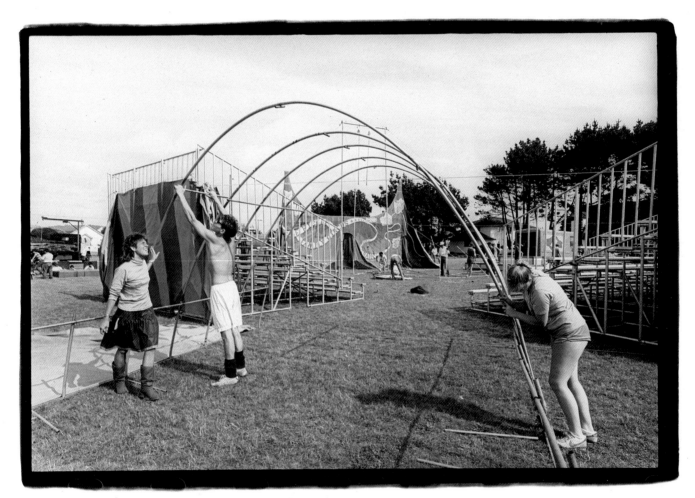

Betty Lucas, Marc Jondall and Gypsy Snider set up the entrance tent

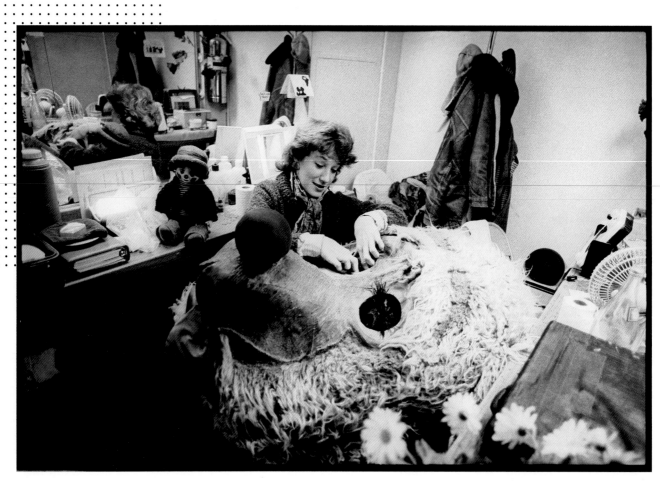

*Domenica Todaro works
on Lummox*

Inside Lummox:
Michael Ohta and
Cecilia Distefano

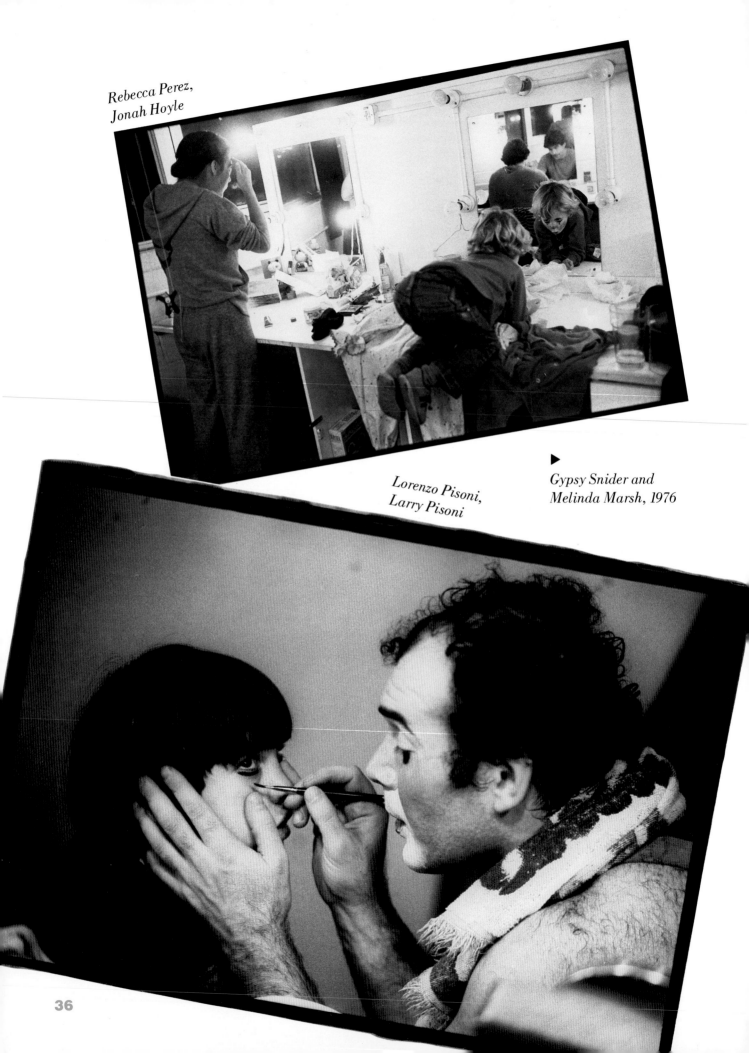

Rebecca Perez,
Jonah Hoyle

Lorenzo Pisoni,
Larry Pisoni

▶

Gypsy Snider and
Melinda Marsh, 1976

36

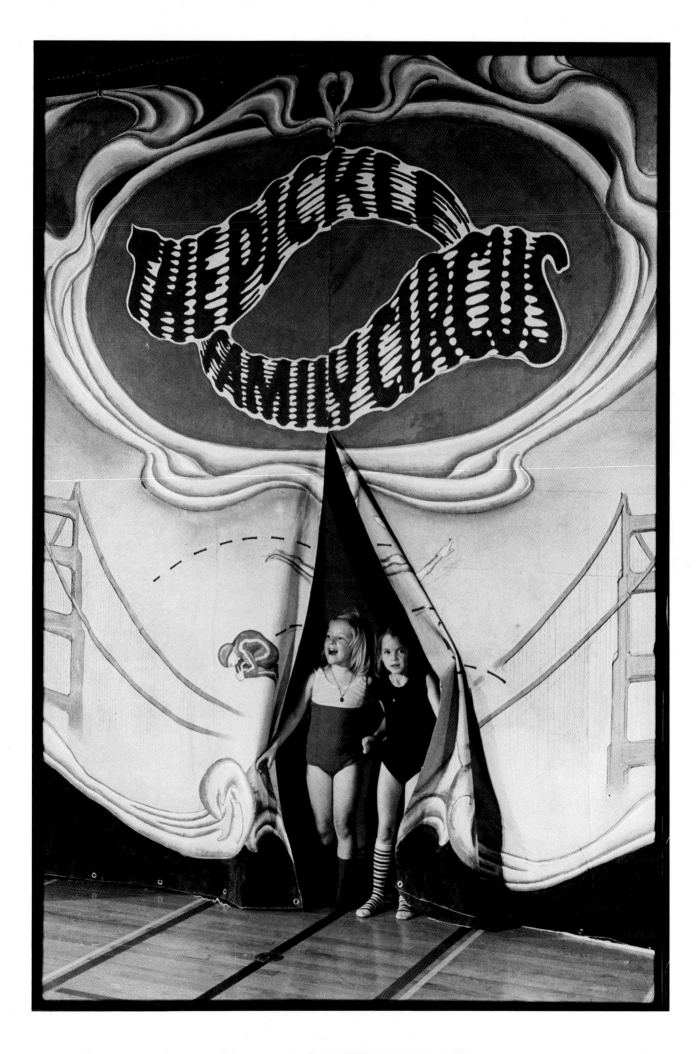

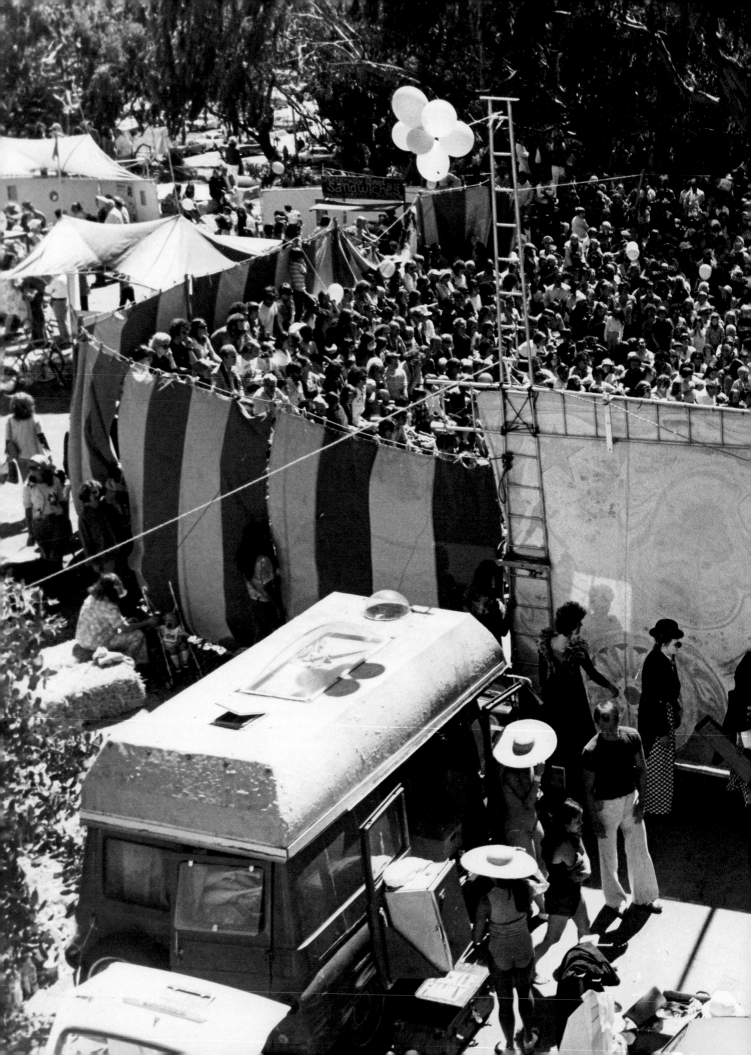

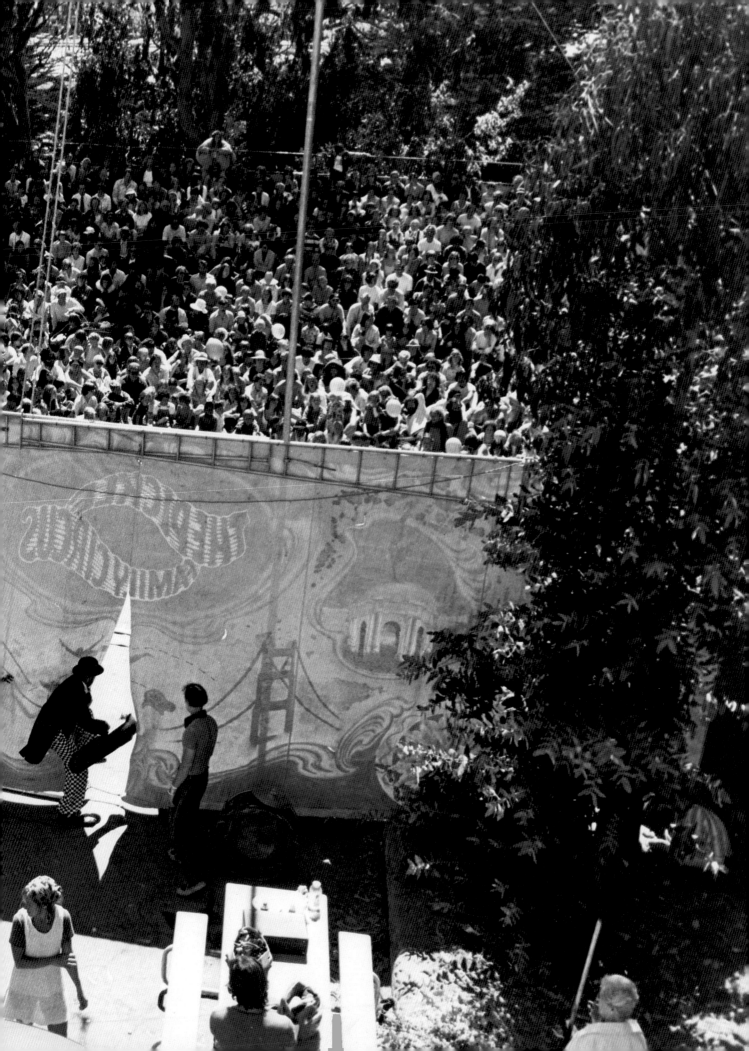

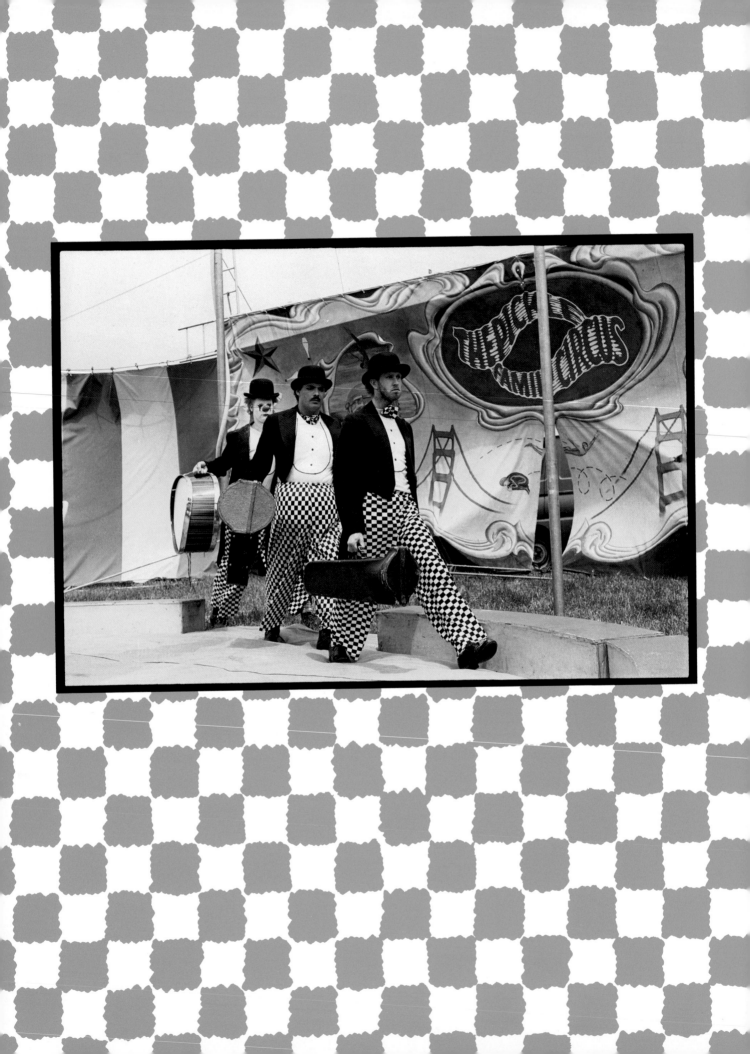

SEND IN THE, OH, NEVER MIND

In the Pickle Family Circus, a clown runs the show. That should tell you something right there.

It's rare, having the clown in charge. Recent circuses have tended toward the Ringling Brothers model, the plummy ringmaster who introduces the acts and, if the audience is truly unlucky, belts out a couple of sentimental ballads. Earlier emcees were often Masters of the Horse, complete with riding boots and whip. The clowns were bumpkins, idiots, at the very best sly tricksters who concealed their cunning under a smokescreen of shuffling and jiving.

The ringmaster was the rationalist, the autocrat, the voice of civilization. The clown was instinctive, realistic, common, a child of nature. The clown never got to be in charge; he probably didn't even want to be in charge.

But within the lumpy body of Lorenzo Pickle, synthesis was achieved. It was definitely his Circus, his Family; he was the paterfamilias (of a noisy family of skilled zanies), but he was not remotely in charge, even if he thought he was. The asylum was run by the lunatics; it seemed probable that Lorenzo was himself a lunatic.

So, almost from its inception, the structure of the Circus announced a victory for the common man. The fool had become king, which meant that every fool had royal blood. Even you; even me.

And, not coincidentally, it meant that the Pickle Family Circus attracted and nurtured and cherished three transcendent clowns: Larry Pisoni, Bill Irwin and Geoff Hoyle. The on-stage contrasts between the three were complex and appealing; often they could get a laugh just by standing next to one another. Irwin was air; Hoyle was fire; Pisoni was earth.

Three Musicians: Irwin, Pisoni and Hoyle

"I think that what Larry and Bill and Geoff did—you probably could never see anywhere else in the United States. It was made up of three people who had three very different kinds of training. The sort of serendipitous magnetism that occurs every once in a while that's accidentally on purpose. They all wandered into each other's lives."
— *Judy Finelli*

"To me, there was a kind of political/emotional/spiritual statement or connection that came through the clown acts that I found really special. It made it more than a grass roots experiment. To me, the clown acts were really the heart of the Circus, because of the relationship they established with the audience. The first few years, we were not exactly high on circus skills. Anyone would admit that. But in a way, it wasn't really crucial to making the Circus wonderful, because there was something else that was really great. The clowns, always the clowns." — *Kimi Okada*

"The first Lorenzo Pickle, the one I did from the very earliest days of the Circus, was a variation on a character that I'd done with the old Pickle Family Jugglers. He had to be someone with some bravado, someone who could

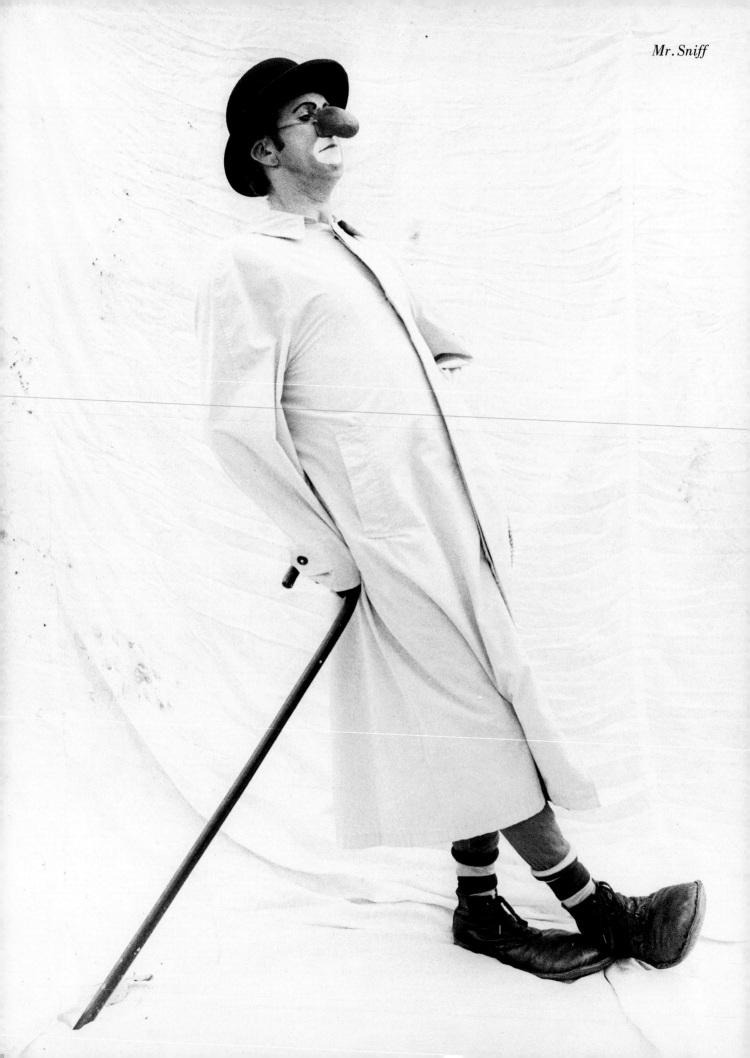

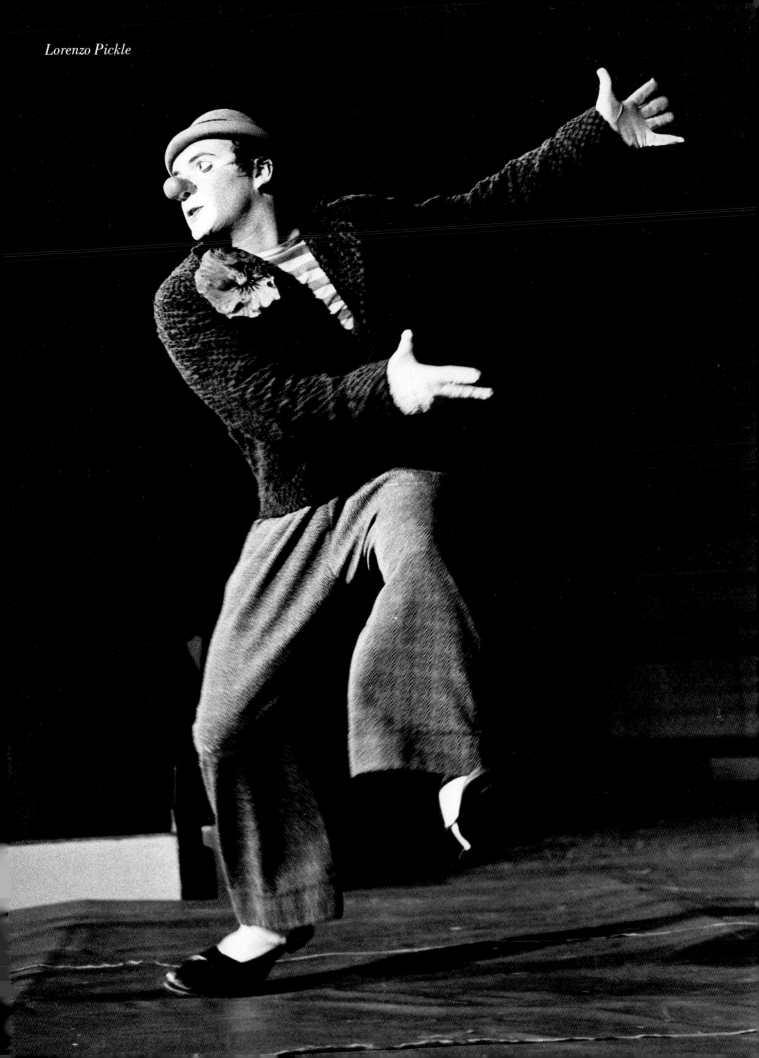

Lorenzo Pickle

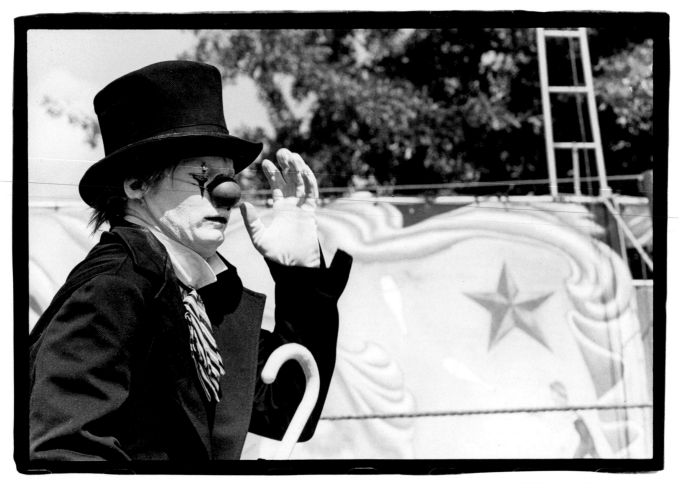

Willy the Clown

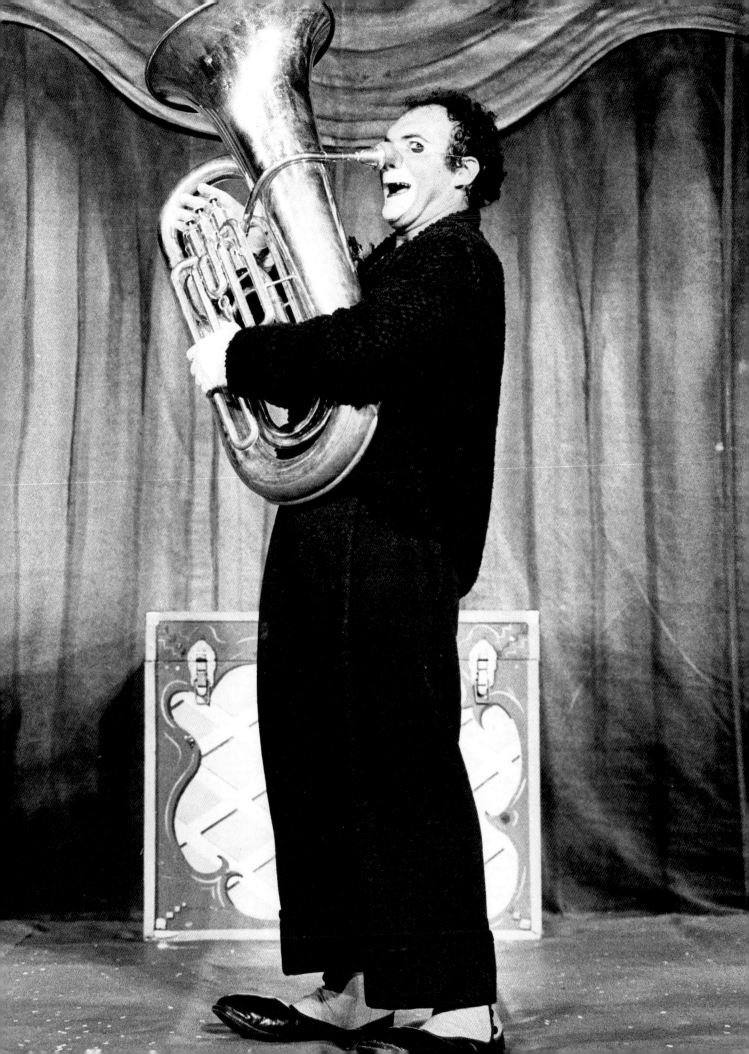

really draw the people in. Sort of a cross between Chico Marx and my grandfather. I did that guy, the Italian circus owner, for a lot of years."

— Larry Pisoni

"I was a bicycle messenger, a few months out of the Ringling Brothers School. I saw an ad that Larry had put in the San Francisco paper, so I called and Peggy answered; she sort of sighed and said 'yeeesssss,' like she'd had about 3000 calls.

"They drove me down to the Mime Troupe studio a few days later so we could have a first look-see at each other. I could tell that Larry didn't know *what* to make of me and I'll tell ya, it was pretty much the same from my end. I had done a whiteface clown at the Ringling school, but Larry was looking for something other than the standard cliche circus clown, something a little more along the European model.

"We talked a lot about it, but in the crush of time, on the first Pickle Family weekend, we ended up with the whiteface, red-nose, red-wig clown. Larry first coined the name Willy, just to give me a name. Willy the Clown was born; Lorenzo Pickle was the midwife.

"Sometimes, on the good days, the Willy character is removed from the limitations of real life—the theatrical 'realism'—but still reflects human foibles. Good stylized clowning abstracts real life—so you're not watching real life, you're watching a refined, almost Kabuki-like version of it. I get these bugs to be a straight actor, but I also don't want to leave behind the magical, larger-than-life clown realm. The question remains unresolved for me; maybe I'm addicted to the irresolution of it all.

"I'm never sure whether as clowns we're trying to get to new places or trying to get back to old places. When it works well, it feels like people are recognizing something from an older tradition. We honkies envy African and Asian cultures with dance/theater traditions that go back over many centuries. In some ways, baggy-pants clowning is the closest thing we have to that kind of cultural tradition. So a lot of what Larry and Geoff and I are trying to do is reconnect with the past.

"And, of course, it's such amazing fun. Like falling down. The thing about falling down, if you do a fall and it gets a certain kind of laugh, a laugh that almost precedes rather than follows the fall, well, it's like falling on cushions of air. You never feel a fall when they laugh like that. When they don't laugh, it's like a misspent effort, and boy, then you feel the bones hit the floor."

— Bill Irwin

"The fundamental thing for a clown, absolutely, is to create a character. That's what clowning is all about, creating this utterly strange but entirely plausible character. And that was Bill; that was Willy the Clown. Once you get a character, then anything can be funny."

— Larry Pisoni

"It was 1975, I think, and somebody said to me, you must come and see this clown, Bill Irwin. So I went down somewhere in the Mission District and saw Peggy and Larry juggling and Bill doing some witty stuff, and I realized that yes, this guy knew what he was doing and it was different from any American clown I'd seen. What I'd seen in most American clowning was cliched pantomime, based on sentimental whiteface, but here was a whiteface clown who actually did a kind of vernacular performance. It really caught my attention.

"I decided to audition for the Circus. The audition was in a gigantic open warehouse called The Farm, and I used the whole space. I did a bit with a

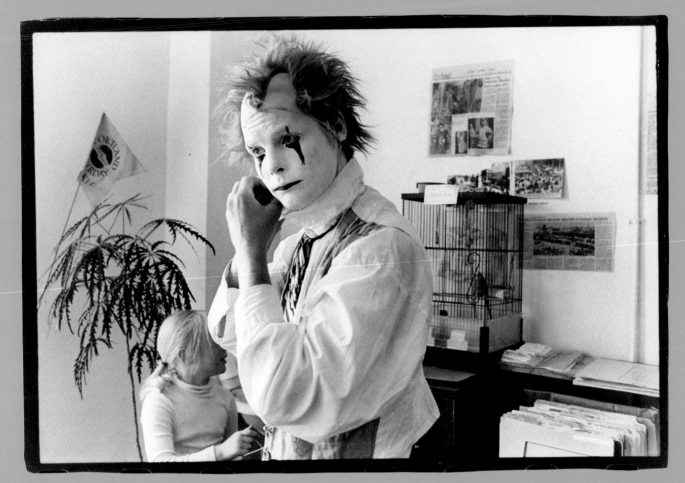

Bill Irwin

violin. I was wearing a long raincoat and fingerless white gloves and baggy pants and a trilby hat and a red nose. My character was called Auguste.

"So Auguste was going to play the violin, but he'd left his bow behind, so he went back to the other end of the warehouse about 100 yards away, made a dreadful clatter with a pile of old coathangers he'd found, and got his bow and came back and was all set and really confident now that he'd gotten his bow and was about ready to play—but he'd left his violin behind when he went to get his bow. And then he didn't have his music, so he fetched his music but he had nowhere to put it so he went and got a music stand and then took ages to figure out how to put the music stand together. He finished up and then didn't have his violin again. I'd just keep walking *all* the way to the other end of the place and then *all* the way back.

"Larry liked it, and I was hired. What neither of us knew then was that Auguste and his violin would become the basis, several years later, for Mr. Sniff."
— *Geoff Hoyle*

For three astonishing years, at a crucial point in the development of the Pickle Family Circus, the three clowns were together. Bill was always Willy; Larry and Geoff each played several parts, according to the demands of the individual sketches. The sketches were developed for the most part improvisationally. They were something between vaudeville turns and one act plays. They were an enormous success.

There were lots of high points, but perhaps the best-remembered was called, simply enough, Three Musicians.

"It was a classic piece. I think its success, both popular and artistic, had to do with the way it incorporated so many clowning stereotypes and archetypes. There were these three types, a fat guy (that was Larry), a little weedy guy (me), and a surreal exotic, a madman (Bill). Each was a very specific character, each had very specific character moves.

"The premise was very simple. Three musicians come out to play some tunes. One has a bass drum; one has a trombone; one has what looks like a huge tuba but turns out to be a tiny pocket cornet. The music gives the act a shape, a dynamic, that is subverted by the classic clown thing of everything going wrong. The three clowns get in the way of each other. There are hat gags and collapsing furniture and absurd mayhem, a kind of dervish activity, that just builds and builds. But in the end they get themselves together and play a whimsical tune.

"I think it just hit a nerve, you know, in the mid-70s. We were moving away from a heavy political style to a comic celebration of people triumphing over adversity. The act implied that cooperation was the way, that sticking together was important, although that message was never overt at all.

"It was a very important time for the three of us. I don't know if it could ever happen again, because of what we have become and how we have diverged, but at that particular time we fitted together so well. Larry and Bill and I fertilized each other, and that was the high of doing it. We respected each other's very different abilities. There was Bill, an eccentric dancer and character clown; and me as a mime and actor and vocal person; and Larry as a juggler and acrobat and burlesque clown. All these things somehow made something that was much greater than our individual strengths."
— *Geoff Hoyle*

"Eventually the three of us decided that we wanted to do something theatrical. We'd been bringing that idea to the clowning anyway, the notion of

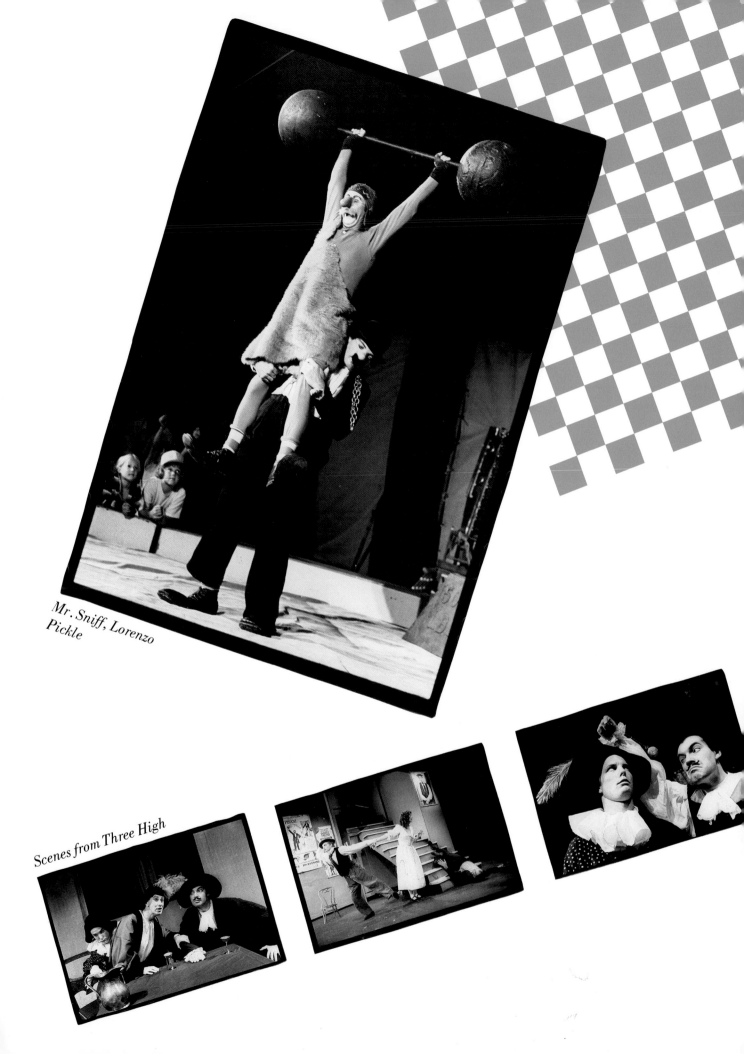

Mr. Sniff, Lorenzo
Pickle

Scenes from Three High

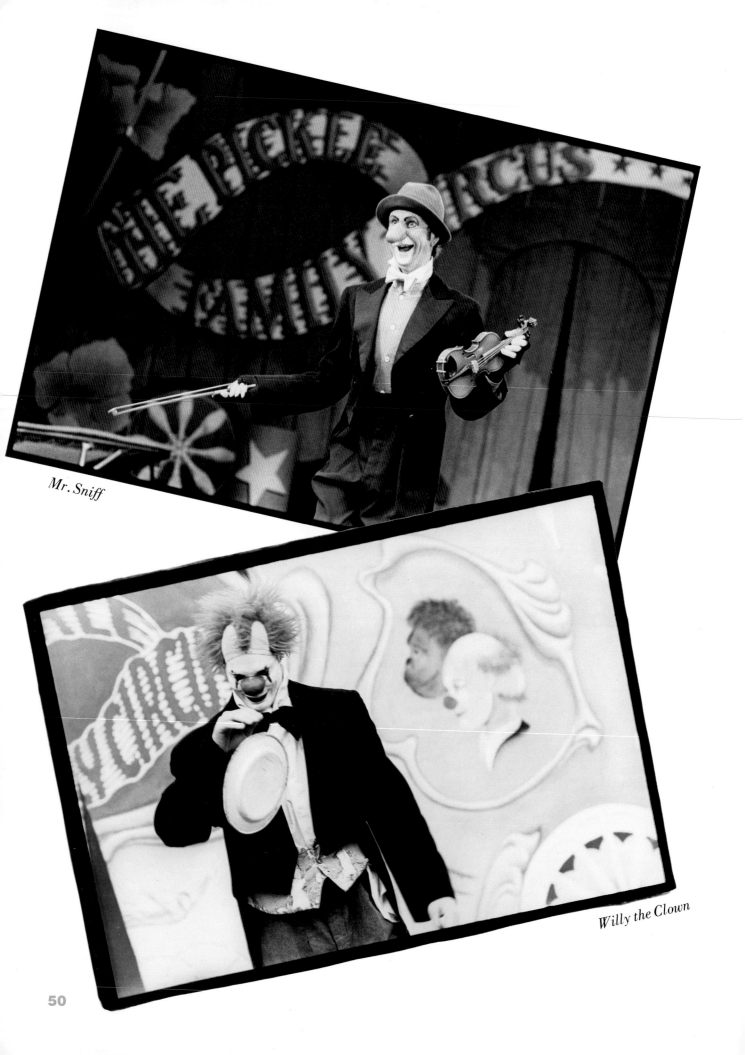

Mr. Sniff

Willy the Clown

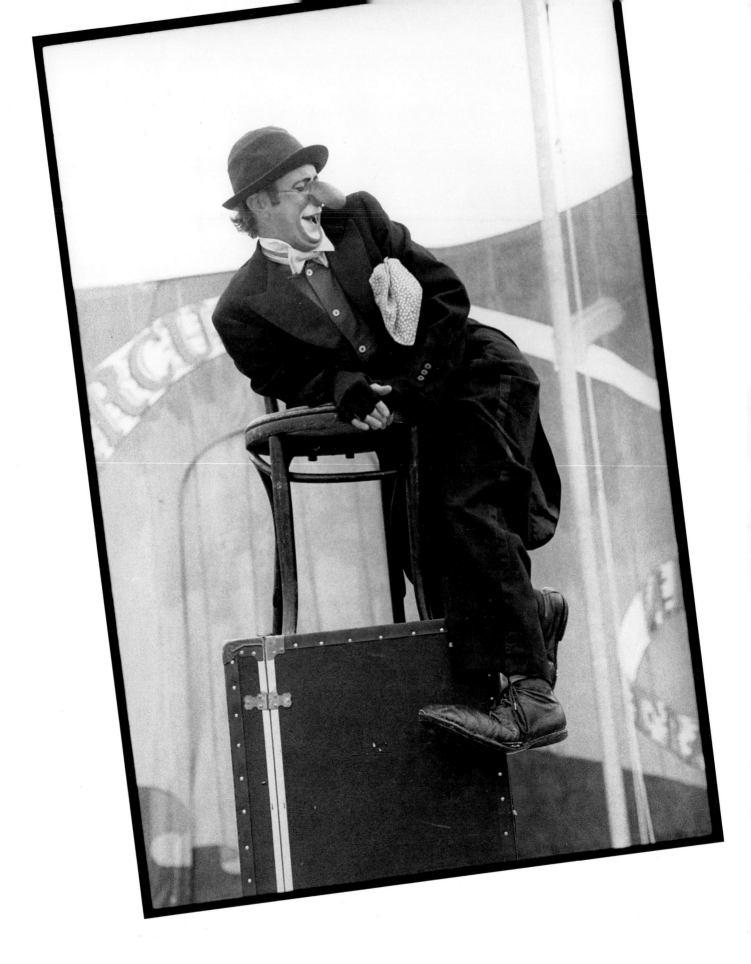

doing small plays in the ring, more like a Buster Keaton movie than anything you'd expect to see at a circus, and so we thought we could expand it still further, into a traditional setting. That was the idea behind Three High, which we opened at the Marine's Memorial Theater.

"Each of us wrote a sketch, and we were supposed to act in each other's sketches, and it almost worked out that way. There were all sorts of problems with the show, weird union stuff and what-not, but on stage it was really the apex of the idea of bringing traditional clowning to the stage. It would be nice to do that again sometime." — *Larry Pisoni*

Bill Irwin left the Pickles in 1979 to pursue his singular clowning vision; the ideas he began developing evolved into "Regard of Flight." Geoff and Larry were required to work as a duo. From this necessity emerged Mr. Sniff, Geoff Hoyle's most vivid clown character.

Marc Jondall, Gypsy Snider; Las Vegas, Nevada

"Mr. Sniff, I always thought, was a classic English eccentric. It's a form of arrogance really; he's like your 80-year-old grandmother who insists that you should drink 20 glasses of water a day. You ask her why and she can't tell you but she still thinks people should drink 20 glasses of water a day. Sniff will go to open his trunk and the latches are on the wrong side but he refuses to believe it. The audience sees that he's wrong, but Sniff doesn't listen.

"Sniff is very different from Willy the Clown. Willy is this childlike character who is always very proud of his achievements; he wants the audience to understand how he's solved a problem. Sniff couldn't care less about the audience and whether it thinks he is competent. He's listening to voices inside his own head." — *Larry Pisoni*

"You learn by doing; that's the experience of the Circus. Sniff is very much tied in with that. He would never have been born without the Circus."
 — *Geoff Hoyle*

Mr. Sniff, Willy the Clown

Geoff Hoyle left the Pickles in 1982—like Irwin before him, he wanted to work on ideas in clowning and acting without the constant demands of the Circus—and then there was one, the Daddy of the Circus, Signor Lorenzo Pickle himself, Larry Pisoni. But Larry was growing increasingly unhappy with the bombastic Italian circus manager he had played for so many years. Lorenzo Pickle needed to reinvent himself; the common man, the uncommon child, had to reassert himself at the center of the action. Clown power, reincarnated.

But creation is never easy.

"One of the ideas that makes me angriest is this American notion of hey, slap on some makeup and you're a clown. All it takes is the outward trimmings; dress up like anybody and do anything. Put a surgical mask on me and give me a scalpel, and I guess I'll go do an appendectomy. That's what the Ringling clown school says: Put on your makeup; if you look like a clown, the audience will think you're a clown. The first day you're in Clown College, you put on makeup. And then you make your costume, way before you know who you are. And then you try to become this thing that you've created for yourself to look like. It's all ass-backwards. So you add a dumb walk that you think goes with it. It's stupid. It's all from the outside in."
 — *Judy Finelli*

"So I began to build a character. Essentially, I was trying to explore the child in myself—I had a pretty awful childhood, which I had tried to forget as

quickly as possible but now that I'm older I want to remember that part of myself again and use it. So I knew that the second Lorenzo Pickle had to be a lot more childlike than the first.

"After I'd developed the character, I began to think about the makeup. The most important thing about clown makeup is that it not hide your face. People don't seem to understand that. Your face is your most important feature as a clown. If you paint a smile on your face, then you've got to be a character that smiles all the time, which is very limiting. Emmett Kelly, you know; the makeup around his mouth was just an oval; he didn't have a painted frown. It was his body that was sad, not his makeup.

"I try to have my makeup be very natural, or as natural as clown's makeup can be; people expect big noses and white paint and stuff, you can't completely get away from that. But I try to show my eyes, so that people concentrate on my eyes and not on my makeup. I have a very heavy brow so I lighten up the area above the eye so there's no shadow there. Then I use a little black eyeliner under the eye to make my eyes even bigger, so I can roll my eyes and everyone in the house can see me.

"The coat I wear is designed to minimize the width of my shoulders. You know, if you look like you're strong, somehow, people are less sympathetic to you. The vulnerability of the character is more acceptable to some people if he looks smaller.

"The red hat I wear is something that I've used as a juggling prop for years, ever since my first street performances. It's my signature piece. It's good to have these symbols, to impart meaning to them. The hat is an extension of me. You could build another Lorenzo Pickle starting with only the hat.

"The trousers are really big and baggy because I like the line they make when I dance. Also, the fact that they're baggy covers up the fact that I'm a little overweight. The legs are cut a little high to expose the spats, which are Lorenzo's pathetic attempt at class. And the red stripes on the shirt are a tribute or a throwback to Joseph Grimaldi, who was a famous English pantomime clown. In many places clowns are called 'joeys,' after Grimaldi, who was considered Britian's greatest clown. He wore red stripes and so do I.

"And then clown shoes, of course, because they're funny and because people expect them. And that's him, Lorenzo, a sort of manchild, a character who is not denying that he is 34 or 35, chronologically, but is communicating in a child-like way.

"I watch our audiences a lot, and in the outdoor performances we invite the kids down from the bleachers so that they can sit right by the ring. And when the adults are alone up there, when they don't feel that their kids are watching them, they respond to material that they might not otherwise laugh at. I like that a lot. I like the fact that adults can come to the show and go through the same process we people in the Circus go through, of discovering the energy and pleasure of childhood.

"I think the clown has a responsibility to present material that can act as a purge for a lot of things that are inside us. Through transference, someone in the audience can get nasty stuff out, purge it, transform it. The more open you are, the more child-like, the more effective that process can be.

"So, as a clown, I find something in myself that needs purging, and I offer it to you, I show it to you, and you experience it as well. A clown character is really only a piece of canvas for the artist, for the individual who is presenting this piece of art. And it's a piece of art about the most important things in human life." — *Larry Pisoni*

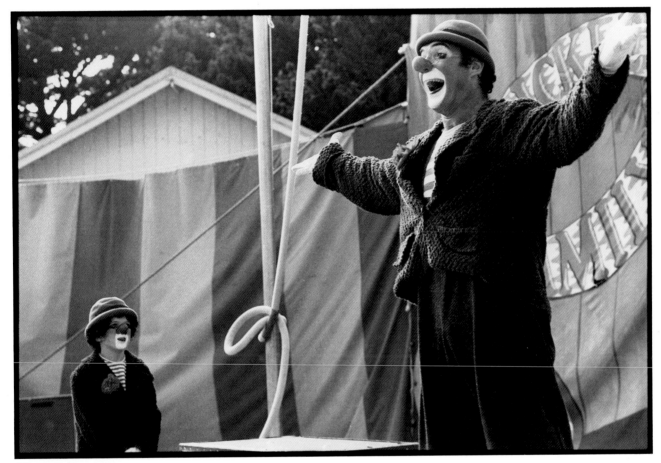

The two Lorenzos

Hoyle and Pisoni
backstage in Arcata,
California

Sniff the Magnificent

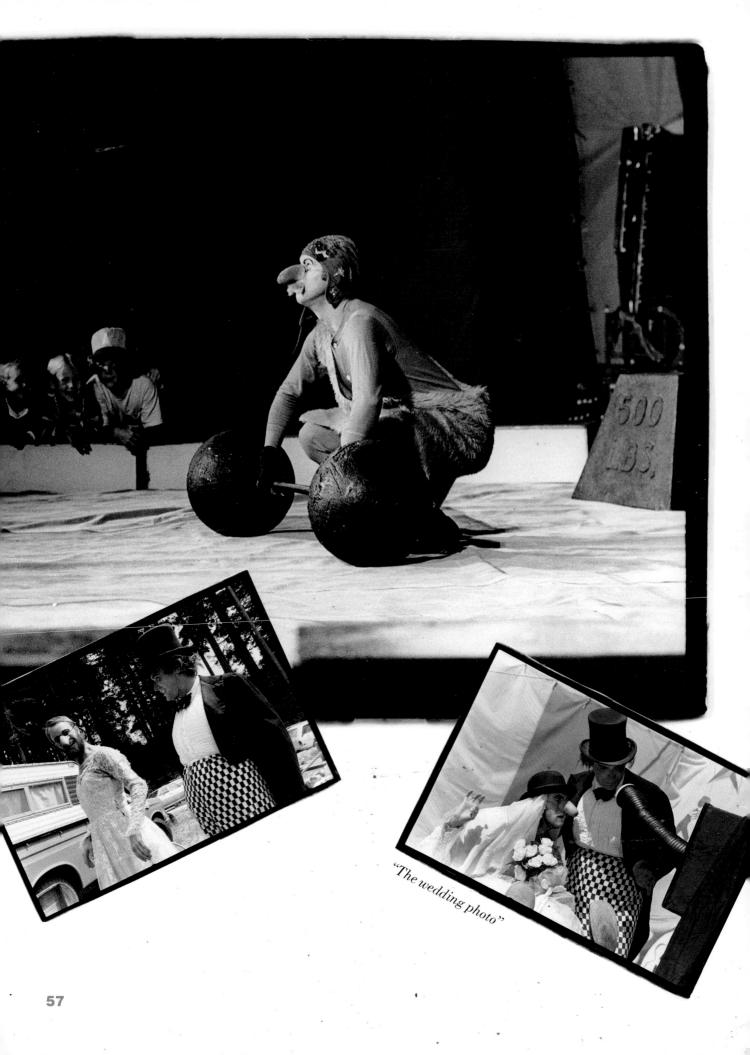

"The wedding photo"

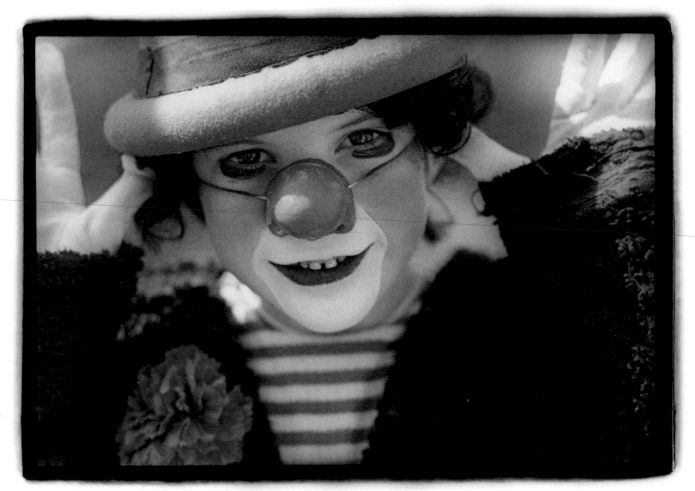

Lorenzo Pisoni

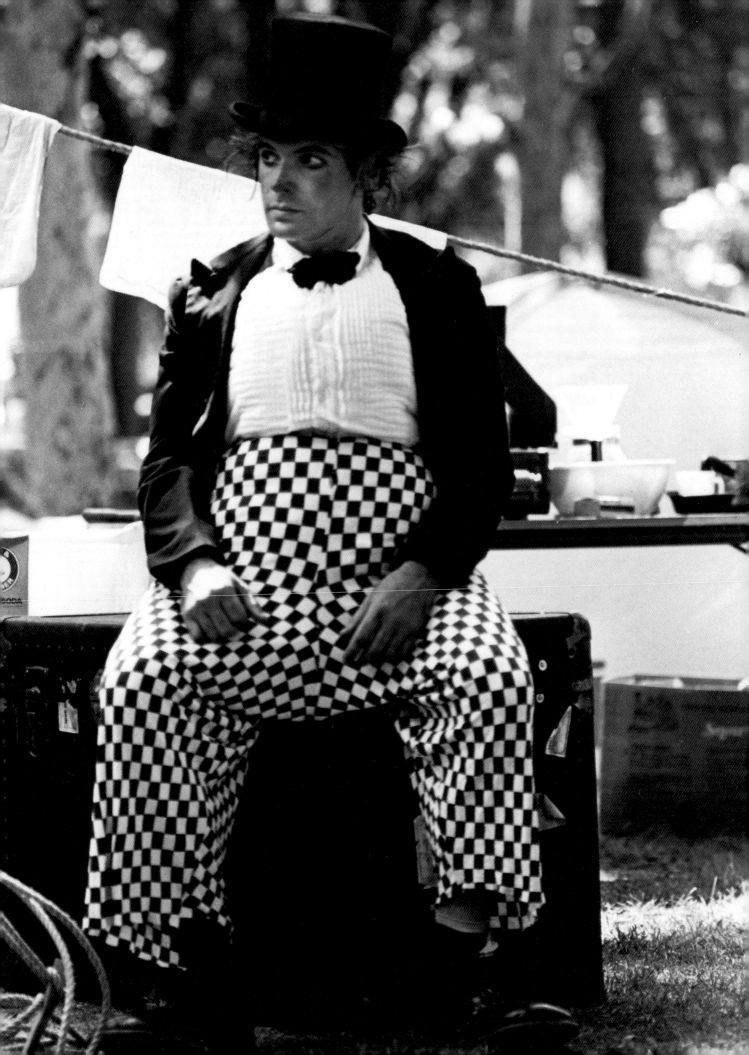

THE SHADOW OF THE PICKLE

"We make it up as we go along. That's the truth." — *Peggy Snider*

"This is what we came to believe: business is art, and art is our business. It just seems that there is a unity to our work. When we write grant proposals or get a new gig somewhere or balance the books or hustle a donation, it's just like juggling or tying down canvas or clowning. It's all the same thing." — *Jo Sonn*

From the beginning, there were contradictions. The Pickle Family Circus was a direct offspring of the San Francisco Mime Troupe, that most militant and collectivist of theatrical aggregations, and yet (unlike the Mime Troupe) it was mostly supported in its fledgling days by government money. (Much of that vital early funding came from the now-defunct CETA program, whose importance can partly be judged by the size of the void it left when it was killed). The Pickle Family Circus was a cooperative, and worked very hard at being one, yet there was a definite hierarchy, a firm sense that everybody got a vote except for several people who got maybe 2 or 5 or 10 votes, depending on what year it was or what the issue was or something else.

These contradictions were not resolved. At its best, the Pickle Family Circus existed on the tension of the dilemma, like a bug on pond water. It skated; it danced; it leapt across the smaller obstacles and swept around the larger ones. At its worst, the PFC tried to kill the contradictions with words; attenuated, rancorous meetings were as much a part of the Pickle experience as joyous performances.

The financial backbone of the PFC was, and is, its community support system. It works like this: a community group—a day care center, or a senior citizens group, or any worthy non-profit organization that has the energy and the will to sponsor the traveling zanies—contracts with the PFC to present (typically) a weekend's worth of shows at a local park or schoolyard or baseball diamond. The group earns $1 from each advance ticket sold, plus all proceeds from the midway it sets up outside the entrance.

"I don't mean to brag—well, maybe I do mean to brag—but it's amazing to me the extent to which we invented everything about the Circus. For instance, other circuses that were sponsored by service organizations went the hit and run route: phone sales in a boiler room somewhere, a prepackaged show, and the sponsoring group would get a very small piece of the action. There was no interaction, so the sponsor didn't learn anything about publicity, and the people who came to see the show didn't remember the sponsor. We began with the idea that it was as important to share our producing skills as it

was to display our performing skills, and just invented the mechanisms that served the idea.

"It was more or less the same in other areas, with something like the sidewall. We decided we needed a sidewall to enclose the space, make it more like a tent. We had no idea how to make it, or how to rig it—we didn't have a tent to hang it from, which complicated things quite a bit—or what material to use. But we went ahead and did it anyway. Maybe some of it goes back to the idea that work should be fun, and it's always more fun to make something up than to copy what has been done before."

— *Peggy Snider*

"Everything we did we created ourselves—an odyssey of wheel invention. Rarely was anything jobbed out. If we did have to go outside the company to get something done, very often the person doing the work either became a company member or at least an ardent supporter. In fact, most of us joined the Circus after being asked to do some job we knew well. For me, it was to coordinate and design all the graphics, particularly the posters.

"Since the PFC was clearly not a money-making proposition, I decided to put the whole graphics budget into producing a full-color poster that would reflect the full-color impact of the show. The colors were always red, yellow and blue—the traditional Pickle colors, reminiscent of the sidewall. The images generally reflected the show's best and most identifiable aspects: the band, various skill acts, most of the clowns. The long thin shape developed because it was easy to put up almost anywhere; after a few years I would see countless kitchens and bathrooms decorated in PFC poster motif.

"I liked that a lot. It's nice that people chose the most often-used rooms in their homes for Pickle posters. I think a lot of people consider us very homey and comfortable." — *Zoë Leader*

"Of course, with all this instantaneous invention, we'd have to make a few adjustments before we got stuff right. In the early days, we'd occasionally run into an organization that thought it would be just *darling* to sponsor a sweet little group like the PFC, and they'd sign the contract that essentially promised that they'd do the work necessary to generate an audience. But then they'd sit back and think that somehow the audience would just materialize on the appointed day.

"Which meant, basically, because of the way the thing was set up, that we were all working for $1.25 a show. Literally. Five bucks a weekend. So we finally said, let's be a tiny bit real! And we instituted the astonishing notion of a guarantee." — *Terry Lorant*

The Pickles now perform a certain percentage of benefit shows for community sponsors who guarantee (as of the summer of 1985) a minimum of $5000 for weekend shows and $3000 for midweek shows. The Pickles provide a lot of advance work (including site inspection and performers to generate media coverage), all publicity materials (including the aforementioned posters) and expertise, the latter in the form of a much-praised and much-imitated Sponsor Workbook, which gives advice on everything from ticket sales to electrical generators to how to barbecue chicken kebob.

Unless things go exceptionally well, the Pickles will lose money on benefit shows in a new location for the first couple of years—the actual cost of one road show, everything included, is between $12,000 and $14,000. Only large and much appreciated grants from the National Endowment for the Arts, the California Arts Council, the San Francisco Hotel Tax Fund, and

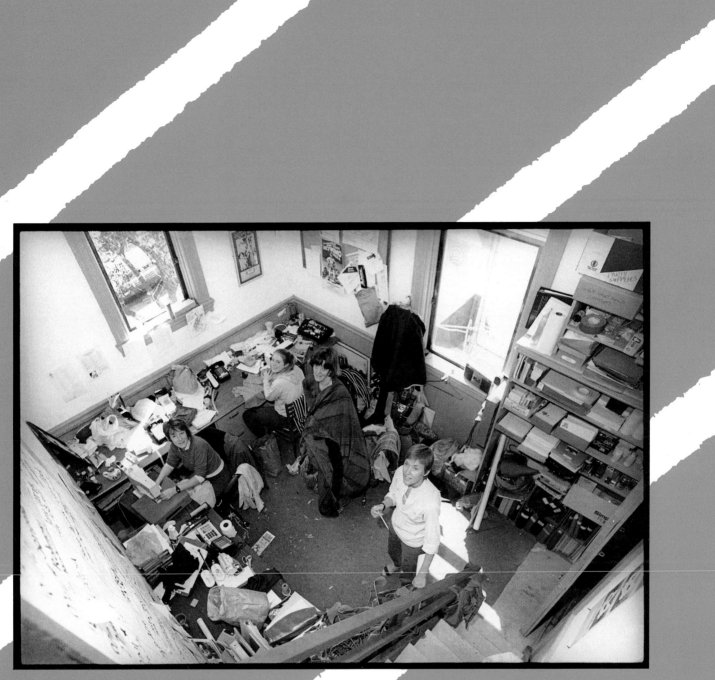

*The Pickle underground
nerve center*

Bananas Childcare Information and Referral has sponsored the Circus every Mother's Day weekend since 1975. The following letter was written in 1984.

Dear Pickles,

Looking back over ten years of sponsoring the Circus, we think of what Mother's Day would be like lolling about at home, being served breakfast in bed by our children...was that ever true? Instead, those weekends in May have been spent watching the transformation of a park into a busy, colorful, noise, bustling creation—kids hanging around watching the bleachers go up, then the "topless" big top—and then, magically, it all disappears leaving a windswept park once again.

We spend our time worrying is there enough helium for the balloons, watching every wisp of cloud in the sky wondering if it's going to turn into a thunderhead, setting up our booths and assigning people to tasks, organizing the other groups running booths and assigning people to tasks, organizing the other groups running booths on the midway to make sure there's plenty of electricity for the coffee pot, the popcorn maker and the juicer, running interference between the group that's selling cookies and the one with brownies, arranging the masses as they arrive early to get the best seats in the tent, working our last minute details with the Circus folk, and then...the music begins and with it the magic of the Circus. We breathe a collective sigh of relief listening to the crowds cheer and applaud.

Oh, oh, intermission! Mobs of parents balancing sno-cones, grabbing balloons, pushing back to their hard won seats. The smiles and good humor evident on all the faces after the show give us new energy for the next one. Five shows later and the band plays its last "ta da..." We can't believe it's time to strike the booths, pick up the litter, help load the bleachers onto the truck...count the money (!)

We watch the clowns sans make-up, the roustabouts, band and artists toiling after hours of performing, now sweating, lugging, loading. All the work, all the joy it produces. We feel fortunate to be a part of it. It's a privilege. Breakfast in bed just leaves crumbs, anyway.

— Arlyce Currie
Bananas

▶
A rapt audience in Pasadena, California

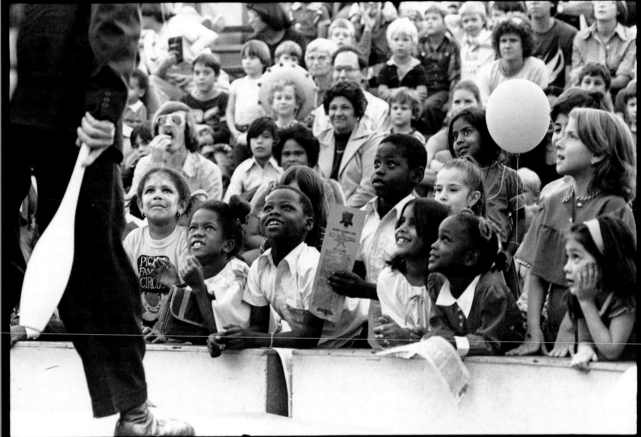

Pickle Family poster art by Zoë Leader

sundry foundations, corporations and individuals make these benefit performances possible. After a few years (the break-even point seems to be around 2000 pre-sold tickets) these shows bring in enough to cover the PFC expenses.

More than 50 percent of the Pickle income has always been earned. Some of that money comes from the self-produced shows (like the annual indoor San Francisco Christmas show) and from other projects. In 1981, for instance, the PFC went uptown with a show called Three High.

"Three High was a crucial turning point. It was a 'real' show in a 'legit' theater. After that, we drew consistently larger crowds to the Circus every weekend, at least in Northern California: After that we consistently got reviewed. And after that, foundation support and private donations really started coming in.

"The secret to keeping it together in the grant world is to decide what you want to do first, and do exactly that. I know that sounds obvious, but a lot of people don't do it. We never tailored our schedule or our shows to please funders. We said, here's what we are, here's how we work, we're worthy; we'd like your support.

"Another big Pickle money secret was that we were always fiscal conservatives. We never overspent. Maybe we'd have a few cash flow problems, but basically, if we didn't have it, we didn't spend it. We had no capital expense budget. If we needed a truck, we'd ask a corporate donor for the money to buy a truck, or bleachers, or whatever. That meant a fair amount of long-range planning, so we had to ask for the money sometime before we positively had to spend it.

"Another thing to mention here is our neighborhood, Potrero Hill, and the amount of support it has given us—and, I think, the amount that we've given back to the Hill. We rent a large old church for our offices and practice space, and the rent has always been way below market value. That's one of the places where politics and money sort of intersect.

"One more thing. We paid nothing for outside labor. Everything was done in-house, or donated. Electrical work; auto repair; painting and sweeping and sewing and whatever was needed. Everybody did everything; there were no distinctions or specific job definitions."

— *Jo Sonn*

"A lot of why I'm doing it, and why I'm doing this in this way, goes back to my work in New York. I was 15 years old and I was trying to get money together to go to art school and be a painter. The only jobs I could get were manual labor. I had to deal with employers and weird foremen, a very demeaning scene. In the construction industry, labor is the bottom rung. And I really decided early that I never wanted to be in a work situation in which I was treated as less than a full human being.

"Anyway, I got a job hauling plaster dust during construction of a space that became the Electric Circus, which was a nightclub with psychedelic lights and rock music and circus acts. I was a big kid, strong; I could work all day; I was always on time, so the people there befriended me. They gave me a job running the follow spot. They had no lighting designer; I'd never done lights before. I went to the library and got some books and learned what I could about stage lighting, and actually made some improvements in the way they lit the acts. So then I became the assistant stage manager too, and then they fired the stage manager and the owner of the club asked me to do the gig. I was sixteen-and-a-half years old, but I said 'yes'. So I ended up repre-

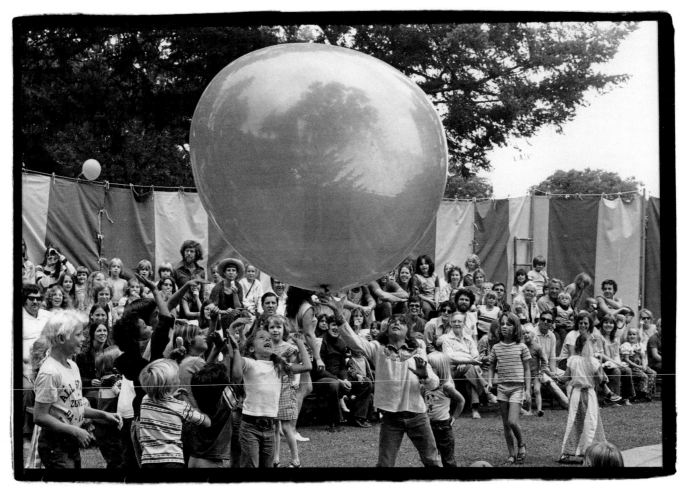

*The big balloon: a
metaphor for circus
finances?*

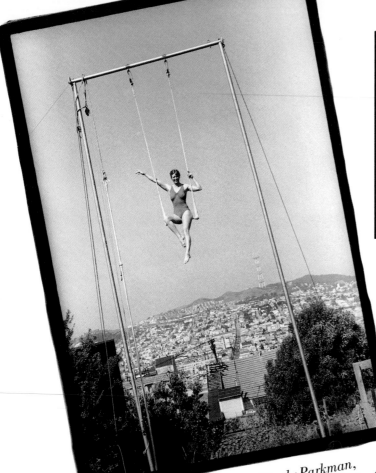

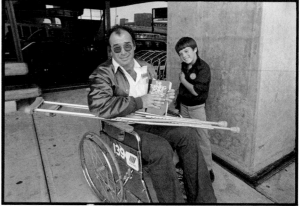

*Larry Pisoni with
crutches, book, son
and broken leg*

*Wendy Parkman,
moments before the fall*

*Jay Laverdure and
Peggy Snider comfort
Rebecca Perez*

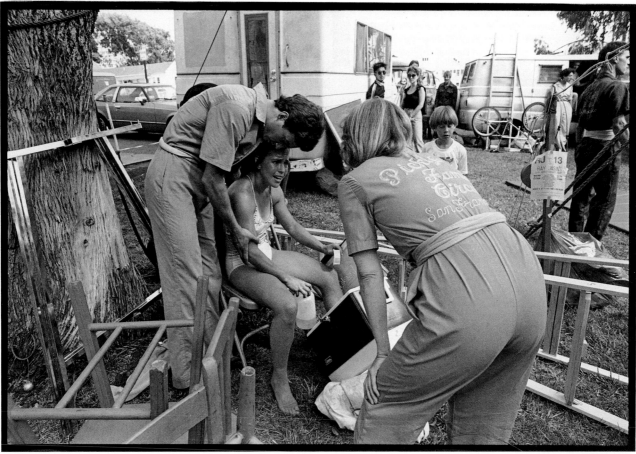

senting the performers who had beefs—a lot of beefs, actually—and I got myself some real labor consciousness."

— Larry Pisoni

"Part of being a PFC apprentice is loving the Circus so much that you're willing to work really hard for it. Learning to tie knots and learning to drill holes is incredible to me, and learning to set up and strike the show. I never held a drill in my life until Michael Ohta taught me how to do it. I thought, if I do nothing else this year, I've helped build this prop and it was a thrill. He could do it in five minutes, and it took him 20 minutes just to show me how to put in the drill bit and figure out which one to use. He took the time to do that. This guy—I didn't even know who he was. It was amazing to me."

— Sara Felder

"I drive the trucks and do the lights and set up the rigging for the trapeze. And the reason why I joined the Circus was that I was impressed with the way that people worked together to get all the work done. In no other situation would you find the bass player carrying bleacher boards with the juggler."

— Michael Ohta

"A lot of bad feelings around here stem from the fact that people are overworked. The Circus just takes an enormous number of hours every week with very little time off. For some people, that's been the case for years and years. Even though almost everybody who has worked for the Circus has worked very hard almost all the time, there is just too much work for too few people. It's inevitable that the situation generates feelings of unequal work, feelings that someone isn't doing enough—or that they're doing more than their share.

"That's been one of the most interesting things about the people I've met at the Circus. In a lot of other situations, I've run into people who've wanted to define a limited amount of work and avoid anything beyond that. In the Circus, I've met a lot of people who've wanted to do an almost unlimited amount of work. So some problems have come up between people who wanted to do the same job. To me, that was new."

— Harvey Robb

Pickle salaries were established on the basis that all kinds of work were equal, therefore all kinds of work deserved the same base pay (currently $250 per week, with earlier variations downward to well below the poverty line). But quantity varies even if quality doesn't, so sundry systems (the Pickles have lost track of precisely how many) were devised to make sure that extra effort was commensurately rewarded.

One system, which sounds faintly silly in retrospect, started with the premise that a full-time job with the Circus takes a lot more than 40 hours per week. Thus, in an effort to curb overwork, a rule was established that no person could have more than one-and-a-half full-time jobs. (Actually, since some Pickle jobs are considered part-time, the load is divided into sixteenths, and no one can be responsible for more than twenty-four-sixteenths worth of jobs). Also, however many jobs a Pickle had, they could not be in more than three distinct areas; say, bookkeeping, performing and making posters.

Equality requires a lot of bookkeeping.

The Circus often offered contracts to Pickle people, although many refused to sign them on general principles, the generalest principle being: "If I say I'm going to do it, I'm going to do it. We don't need a piece of paper."

A contract is, of course, no guarantee against job-related injuries;

preparation, caution and luck are the only known antidotes, and even they are not 100 percent effective. Being in a circus is a dangerous way to earn a living.

"You can break your body doing just about any of the skills in the show, especially the acrobatics, and you can get hurt during the set up or the strike. It used to be that every April, during rehearsals, something awful would happen. Lots of ankle accidents. Both Willy and Geoff began two different seasons with their legs or feet in a cast. Before the very first show in 1975, Larry sliced his hand open. He has since broken his hand and his leg. Three weeks after he broke his leg last season, Peggy broke her foot.

"Once we set up the trapeze in the backyard of Larry and Peggy's house so that Wendy could get her first practice at full height, and we invited Eyewitness News over to watch her practice. We thought it would be good publicity. So, in the middle of her routine, Wendy let go of the trap and fell 15 feet as the cameras were rolling. But she was so determined to have a successful practice that she climbed back up and finished her routine and then came down again before she really fell to pieces. Turned out she only had a bad sprain, but it still took four weeks to heal."
— *Terry Lorant*

So it's dangerous, difficult, low-paying; a constant hassle, a constant struggle. The question does keep recurring: Why do they do it?

"Look at what people in the Circus have to go through. You never make enough money to get ahead or even get particularly secure. You live in a tent. You're constantly on the road. Family life can be impossible; I've seen families break up because of it. It's a very hard life.

"But you do get to live your ideals. That's really it. When I left the Circus, after a while I realized that I was no longer surrounded by people living their ideals. And it affected me to some extent, just as the Circus way of being affected me in a positive sense. If you're around people who are trying to live their ideals, you're going to try too. It's so hard, given the system, with everything based on competition and love of money, to actually keep those other goals in mind. But, to an amazing degree, that's what people in the Circus are doing." — *Randy Craig*

"Circus Oz [an Australian circus group] comes right out and says, 'We're the non-sexist, non-racist, anti-nuke Circus Oz.' I can't see the PFC doing that. But simply ignoring what's going on isn't it either. Something should creep in. We just have to do our best to speed along the next pendulum swing back to a more humane state in the world, whatever it was that was cooking during the Sixties. If we keep slugging in there, maybe it'll come a couple of days sooner."
— *Judy Finelli*

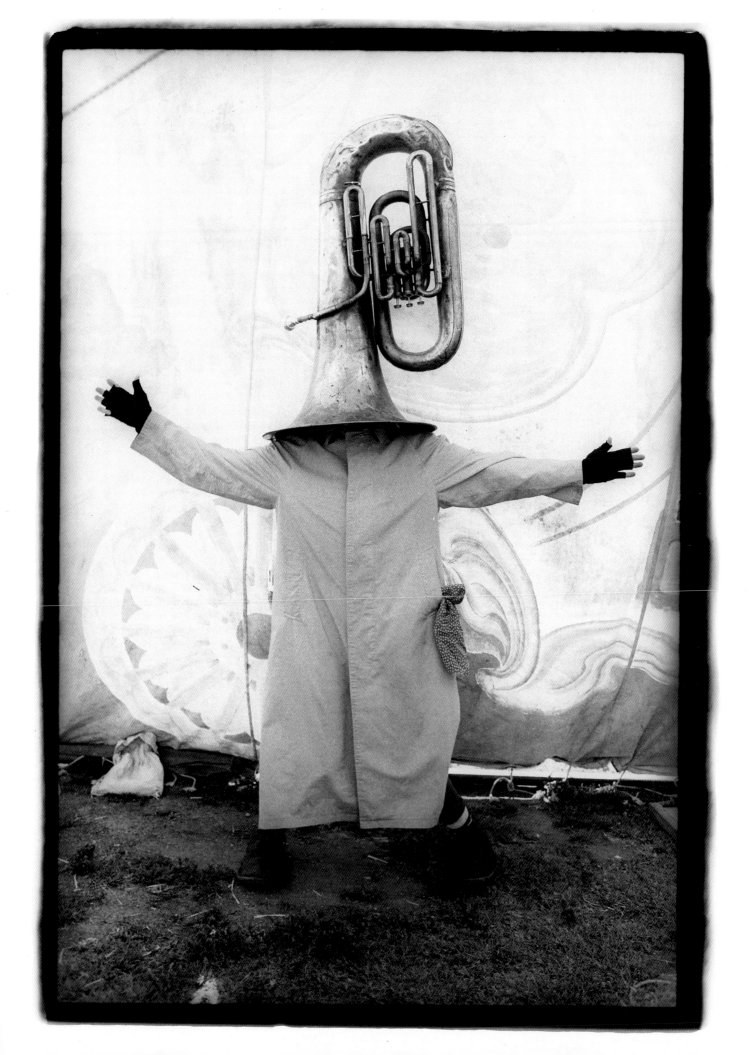

THE BIG JUGGLE

Anybody who juggles—indeed, anybody who even watches for any length of time—begins to think of juggling as a metaphor for life. Keep a lot of balls in the air. Don't stop or you'll drop everything. Practice until instinct takes over. You enter into the cavern of juggling for only a moment, thinking that you won't stay long, that you're just here for a lark, until dinner's ready or the movie starts, and the next thing you know the inherent ideas—juggling is filled with ideas—will begin to dominate your life.

Insinuatin' rhythm. Here: Catch.

It's a discipline crammed with lessons; a non-verbal teaching tool; a skill with an ever-receding benchmark of perfection. Also, it's fun to watch. Also, it's even more fun to do.

"Juggling is one of those first-fix-is-free activities. You can learn to do a three-ball cascade pretty quickly, within a couple of hours. And once you've done that, well, you can't believe that you just did something that silly and that you got such a charge out of it. And once you've done 1-2-3 catch, then you can do 1-2-3-4 catch, and every little increment feels like such a great success. And when you learn to pass with someone else—that's when the kicks really start." — *Terry Lorant*

"Juggling presented a challenge for me that made me want to practice and practice. It was the first sign I had that I was a fanatic."

— *Marc Jondall*

Peggy and Lorenzo Pickle

"When you see somebody throwing seven objects in the air at a circus and keep them going, that person is balanced. That person is centered. He's controlling the trajectory of inanimate objects. His heart and mind is going a mile a minute. It's an amazing thing to see."

— *Larry Pisoni*

Juggling has been an integral part of the Pickle Family since before the beginning. There's never been a show without a juggling act. The clown acts and the acrobatics and (when there was one) the trapeze act might have been the flash and fire of the Circus (when they worked, they certainly were), but the juggle was the through-line, the baseline, the *sine qua non*.

This is not a coincidence.

"I was 17, in New York City, seriously unemployed with occasional gigs as a piano mover. Then Hovey Burgess asked me to join a company he was putting together. I loved going out to Central Park with the Circo Dell'Arte on weekends and performing with eight other people."

— *Larry Pisoni*

"Hovey Burgess is the mother cockroach of jugglers. Cockroaches lay 600,000 eggs a year. If you see my point."

— *Phil Marsh*

75

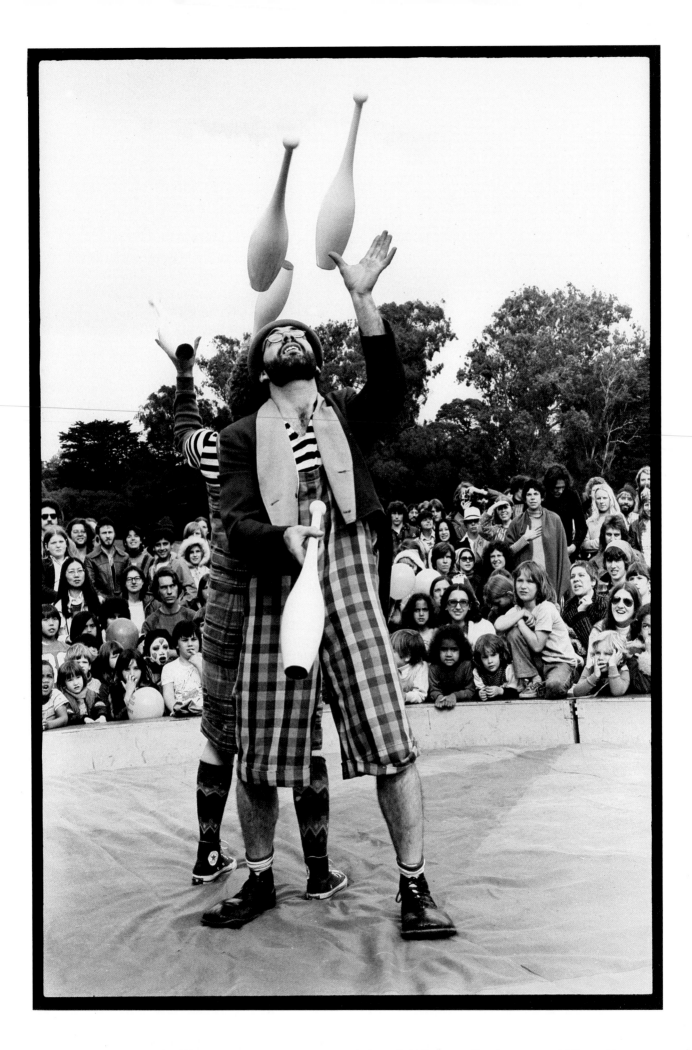

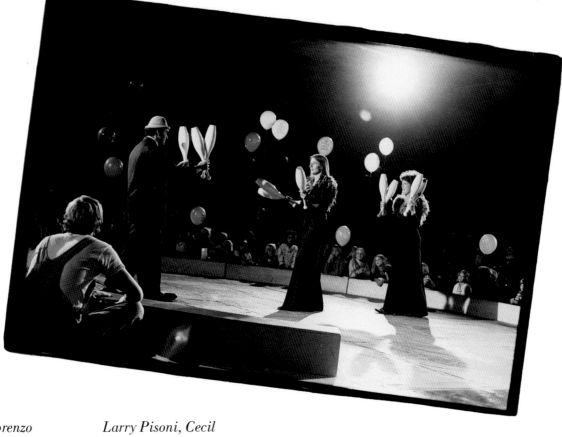

◀

Peggy and Lorenzo
Pickle, 1976

Larry Pisoni, Cecil
MacKinnon, Peggy
Snider

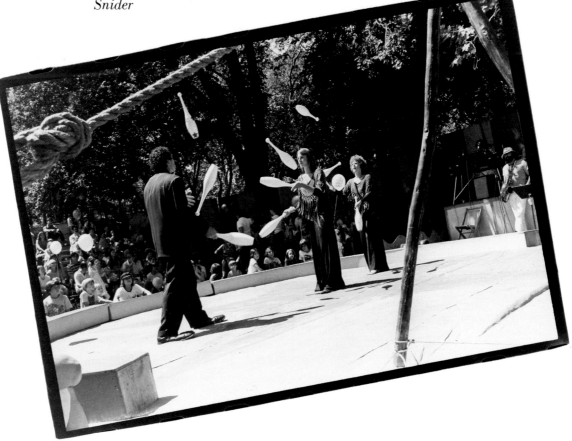

"I see it as sort of a generational thing. There was a school, really, very recently in terms of time but actually more like an old school, a strict school. The first generation was Judy Finelli and Hovey, who was Judy's husband at the time. Then came Larry and Cecil MacKinnon, who were the second generation. I met Cecil through Larry; I guess I was the first member of the third generation. And Larry and Cecil and I were the Pickle Family Jugglers, which was the forerunner of the Circus.

"The Pickle Family Jugglers went everywhere. We performed in the parks and on college campuses; we performed at corporate Christmas parties with some lame orchestra behind us that was playing our music about ten times too slow. We even juggled on the radio. Don't ask."

— Peggy Snider

"Judy Finelli! She's been an idol in my life. *Every* juggler knows about Judy Finelli. In fact, for about five years, I've had a little picture of her and Hovey passing ten clubs. Well, all of a sudden, when I joined the Circus, there she was in my life. She can look at my five balls and make suggestions about how to do it better. I had thought that nobody could teach me juggling at this point, because all I have to do is practice. It's such a thrill to have someone say, this is how you get better, you do this exercise and this exercise. And, well, you could be doing seven balls three months from now."

— Sara Felder

"So the tradition had certain rules, or maybe just certain matters of etiquette. There's good juggling etiquette and bad juggling etiquette, at least from my point of view. That's why it's hard to learn juggling from a book; you don't get the tradition.

"One key to our attitude, or our etiquette, is that the responsibility for the pass is with the passer. You should not be required to catch any damn thing I throw your way; if you miss it, likely as not, I blew it. On the other hand, the responsibility for correcting the problem is with the person closest to the dropped club. It's up to them to figure out whether they can pick up the club while the act is still going on, or whether they should say 'stop'.

"Another rule, which seems obvious but really isn't, is: It's better not to get hit in the head with a club than to get hit in the head with a club. There are some juggling acts that are very macho, where they throw the stuff right at you and dare you to catch it. But we make the throws out to the side, so the penalty for error is a dropped club, which is embarrassing but it won't give you a concussion.

"And it's better to practice everything a million times. The Pickle Family Jugglers did formation juggling with clubs—that's basically what I am, a club passer, I'm not really a solo juggler at all—Larry and I would start out by doing the routines with balls. Balls are harder; they're littler, and there is a lot less to hang on to. So if you can get your accuracy down with balls, then you can certainly do it with clubs.

"Accuracy gives you time, and time gives you the ability to make changes without freaking out. Say you find that you're 180 degrees out of sync, that you're doing stuff with your right hand that you should be doing with your left hand. A solution to that is to make a long slow pass to yourself at just the right moment. That's actually the exciting part of juggling, correcting those things without missing a beat—or even more interesting, by missing a beat. The audience may not even be aware of it—if you do it well, they're not—but they do get the sizzle.

"We're constantly giving notes to each other on stage. Smiling all the time, of course, not moving our lips very much, but we're always saying 'inside'

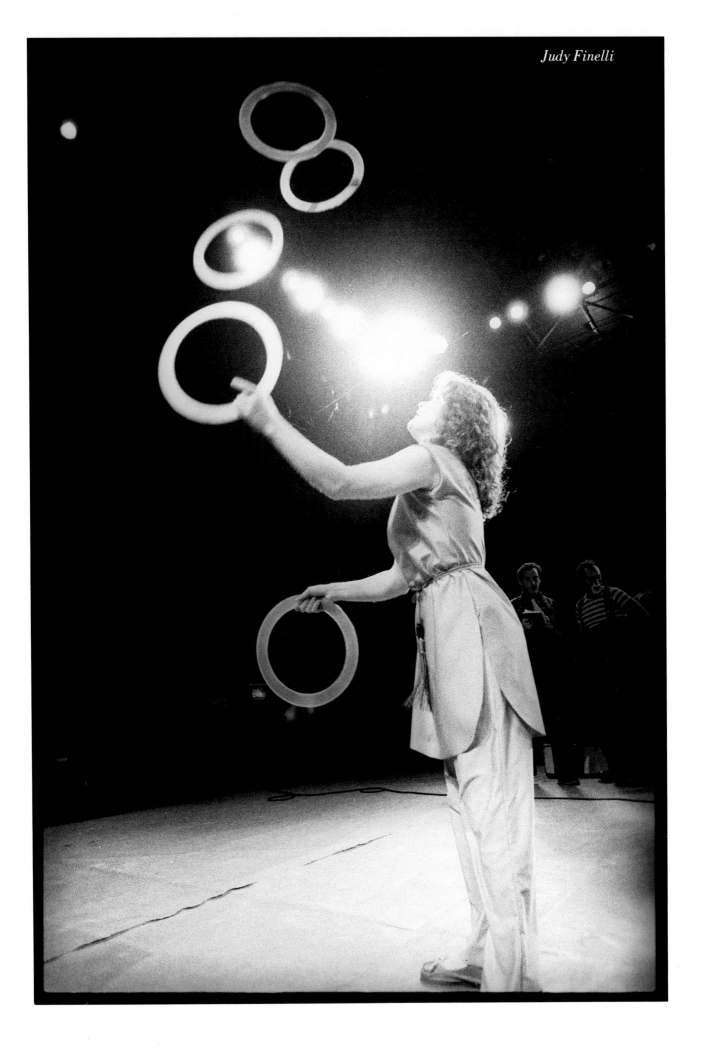

Judy Finelli

Join the club: Wendy Parkman, Jay Laverdure, Derique McGee, Marc Jondall, Judy Finelli, Robin Hood, Rebecca Perez, Robert Burkhardt

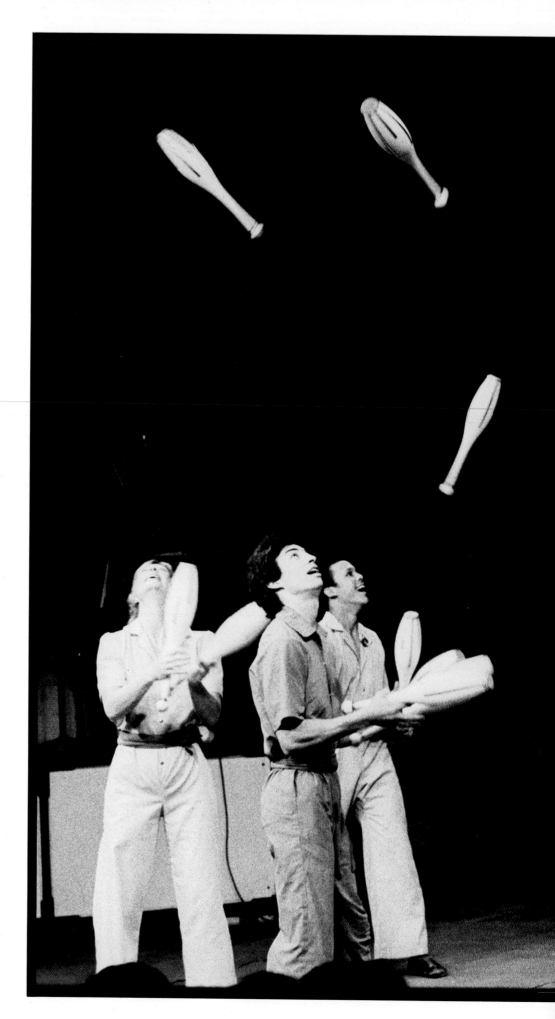

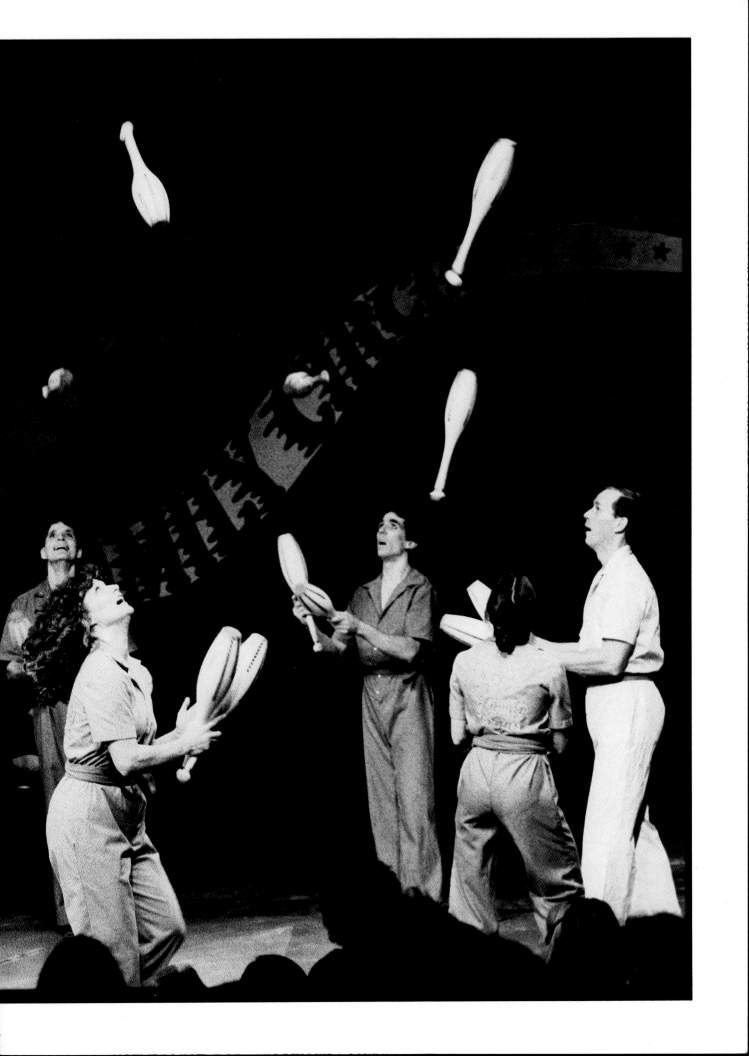

or 'outside' or 'long' or 'short' or 'overturned' or 'underturned'. If I say 'inside', that means the last throw was inside and I want the next one a bit more outside. You have to have an agreement on that, or it's chaos.

"And that's where practice, and to a certain extent eye contact, is so important. After 12 years of working with Larry, there was so much we knew because of what we could see in each other's eyes."

— *Peggy Snider*

Rules and traditions; a link with the past; a way of doing things. The Pickle Family Circus did not have the flashiest jugglers in the world, nor the most innovative, nor the most talented. So what made their juggling acts so memorable?

"One of the things that made Peggy and Larry's juggling act so great, why it was so wonderful to watch, was that you really cared because there were two people out there who had a performing relationship and they're *people*, not just incredible jugglers.

"Watching Ringling Brothers, you see incredible technical feats, and by the end of the evening you're jaded. Oh gee, they just juggled eight million balls. You can appreciate it for an instant, but I think there's a tolerance level for admiration and appreciation of tricks. It's when the tricks are put into a context that they become transcendent."

— *Kimi Okada*

"Some groups eat together; in the early days, the Pickles juggled together. Most everyone who had worked in the office would take breaks during the day and go into the studio space to practice their juggling.

"So if I'm really uptight working on booking the season and I'm waiting on a contract that's taking forever, or if I know that I'm going to have multiple anxiety attacks for the next two months worrying about whether the season is going to come together, there's a huge satisfaction in going out and throwing a 3-3-10 with somebody. It looks good; it has a beginning and an end; usually I laugh somewhere along the line." — *Terry Lorant*

"The Big Juggle ends the show, and all the schmucks get up there and drop clubs. It's not the tightest or most beautiful juggling act in the world, but there's nothing like it. There's something very intangible and wonderful about it, that someone who's never had performing experience before can become a juggler.

"There are very few organizations that would take a chance on some poor guy dropping a club and ruining the end of a show. The Pickles are willing to do that, just to help and train the schmuck at the beginning of the line who only has to throw the club twice. Everybody else has got to do feeds and count clubs, all that stuff, and the newcomer just has to throw twice. And for the first 17 shows, he'll mess up. Right? He will drop, and the Big Juggle will be weak. But by the end of the season—*Wow!*"

— *Randy Craig*

"Maybe that's why we never concentrated on solo juggling. It had to do with the philosophy of the show. We never begin or end with a solo act. We used the Big Juggle as an expression of that: Together we can do things that we can't do alone. Of course, the reverse is also true."

— *Peggy Snider*

The mind of a juggler. Everything is in the air; everything is catchable. Your basic yins and your equally basic yangs. Discipline and hedonism; tension and release.

Here: Catch.

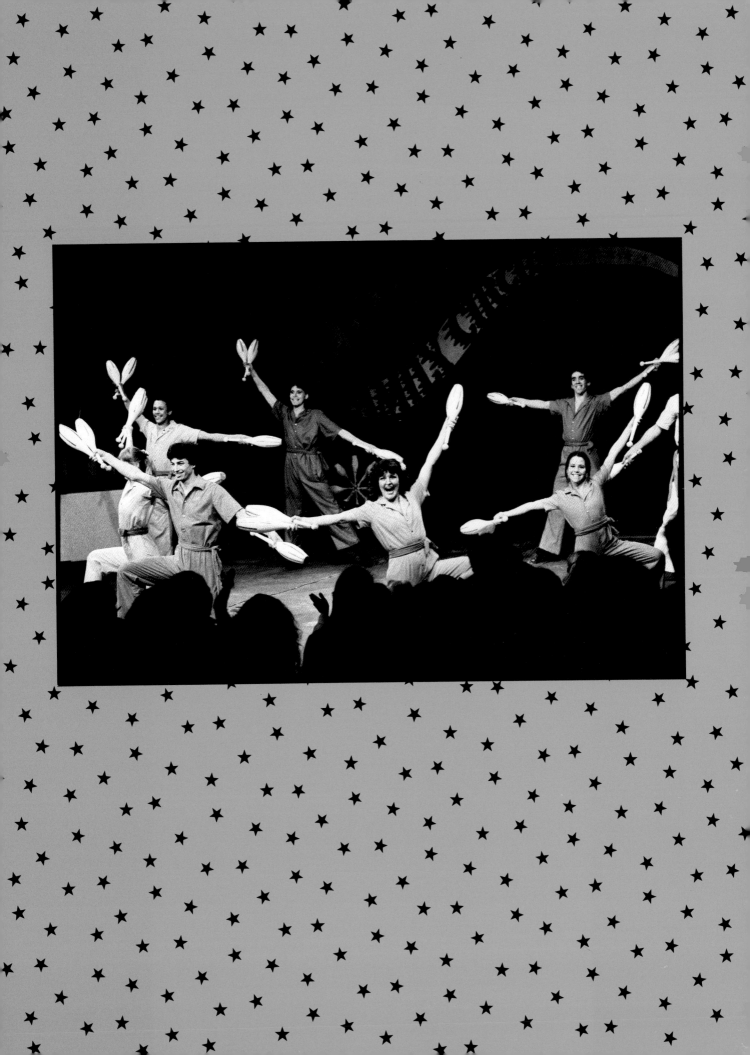

"If there's any perfection on earth, it's up in the air."
 — *Sando Counts*
"Something you realize very early when you take ballet: There's no way to cheat in ballet. That goes double for the trapeze: There's no way to cheat up in the air."
 — *Wendy Parkman*
"I'm not particularly pleased with most circus's presentation of skill acts. I'm not particularly interested in watching people risk their lives. Life is much too precious. It's like paying to see somebody stand on the edge of a cliff; maybe they'll fall off and maybe they won't regardless of the skills involved. The fact that a trapeze artist uses a gimmick to slide to his heels while swinging on a trapeze so that it looks like he's going to fall; that's not interesting. He doesn't need that sort of stuff; he's a very accomplished athlete; why is he trying to trick us? If he dies, what do I get? I've seen people fall from a high wire; I've seen people fall from a trapeze. I didn't get a good feeling when they hit the ground.

"What I *am* interested in is seeing people make beautiful images and project them and demonstrate the power of a human being. There's enormous beauty in these acts, whether it's walking on a wire or tumbling on the ground or flying on a trapeze. It doesn't need any tricks. It's real magic."
 — *Larry Pisoni*

Real magic. Acrobatics, tumbling, trampoline work, tight wire, slack wire, trapeze; seemingly impossible activities, defying what we know of the muscular and psychological limits of human beings; no hidden wires, no optical illusions, no smoke, no mirrors, nothing up their sleeves but arms. When feet leave the ground, the mystery of the circus starts.

Corollary one, obvious when you think about it: Real magic is hard work, usually very boring and occasionally very dangerous. Because there's no way to cheat in the air, there's no way to cheat during the practice sessions either; the penalties for sloth are immediate and dramatic.

So we have incredible effort in pursuit of effortlessness; the Puritan work ethic placed at the service of pagan marvels.

The PFC has had three trapeze artists: Dizzy Heights, Wendy Parkman and Rebecca Perez.

"My life back then was amazing. I'd wake up and go running, and then go to ballet class, and then go to the Circus rehearsal and do my act, then I'd do weight training, then I'd have a sauna and that would be the day. I'd often forget to eat; literally, people would have to remind me. I'm not sure it's healthy to devote that much time to perfecting one little thing."
 — *Wendy Parkman*

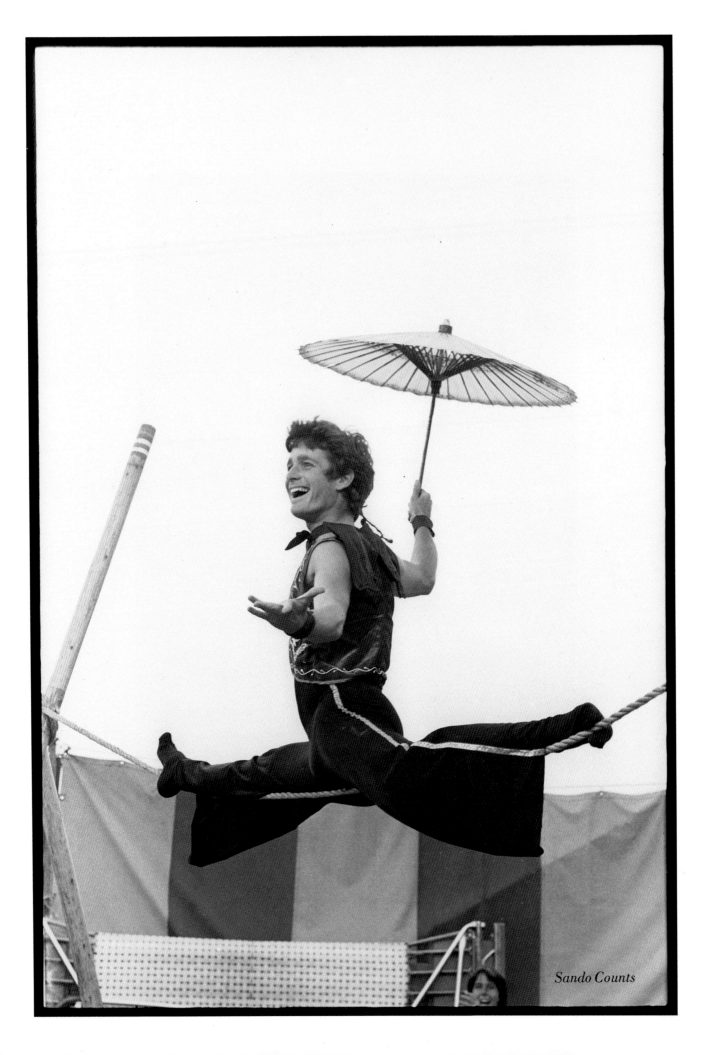

Sando Counts

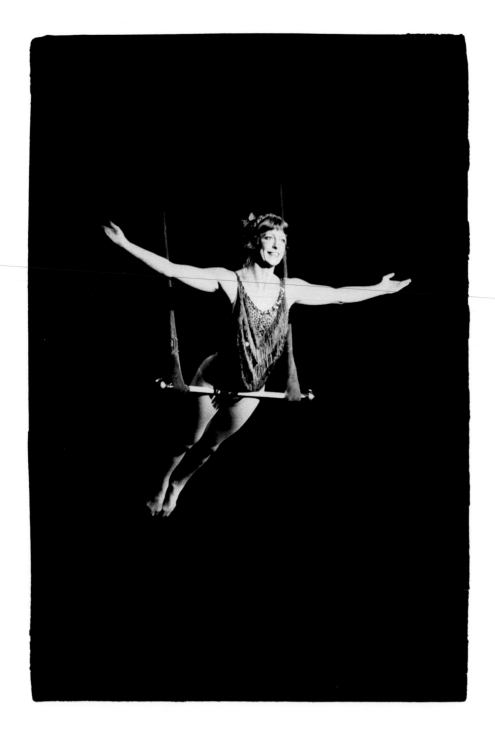

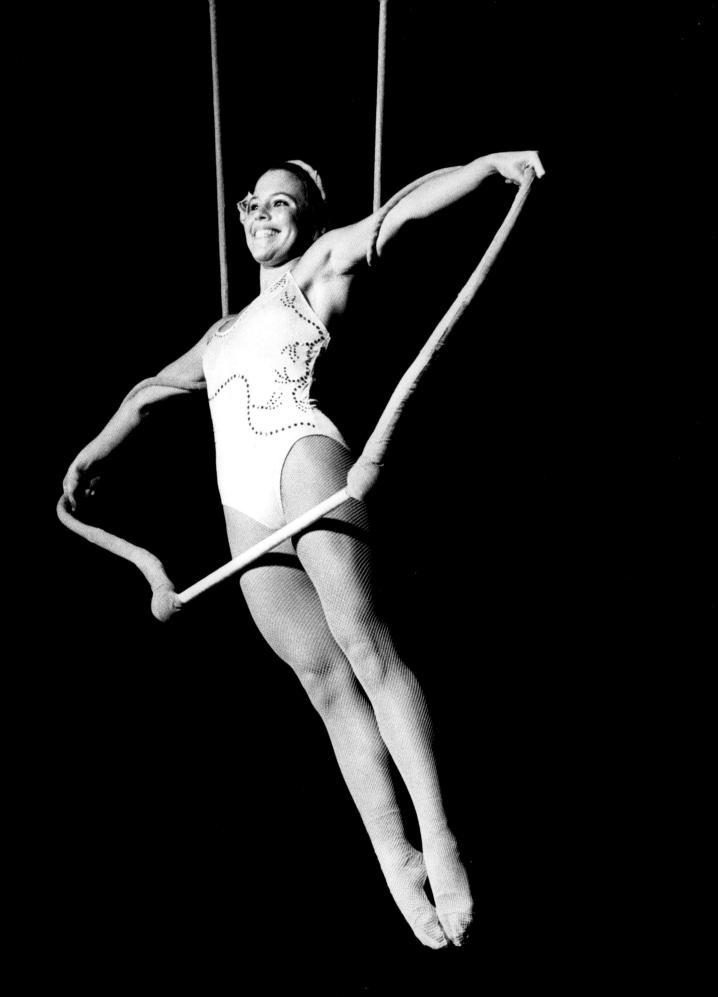

Rebecca Perez

"When I first started working on the trapeze act, I just worked on the bar itself for an hour and a half a day, seven days a week. And my body was one big bruise. Then, at about the time the bruises started to go, my ankles got torn. I thought I'd never get the act together.

"Sometimes it gets real lonely on the trapeze all by yourself. Sometimes I talk to myself, especially when I'm tired and need extra concentration. I was terrified of heights before I did this. The first time we set the trap at full height, I got to one trick where I had to roll forward, and I just couldn't do it. So I came down and rested a bit and played the music for the act. Music really helps. And smiling. Smiling *makes* you relax. Even with all that, though, I got stuck again, and people on the ground had to talk me through it.

"So that's one reason I talk. 'Look at all these people,' I say to myself, 'they're smiling. Look at all these kids. They'd *hate* to see you fall.'"
— *Rebecca Perez*

"I never really had much of a fear of heights. I wasn't one of those people who'd stand at the edge of cliffs or anything, which I think is dangerous and silly, but I never really thought about it. So I really wasn't ever too scared on the trapeze. Anyway, the fear lessens as you get stronger. By the third year, I felt as though I were in total control. I'd be up there thinking that maybe 20 feet was a little too low. That's one of the reasons I stopped, actually; the feeling that I was getting a little cocky and might be tempted to press my luck.

"By then, the act was close to the ideal, not a moment or a breath out of place, absolutely fluid, nothing superfluous. I was completely relaxed, that 'Queen of the Air' person that little girls see at the circus."
— *Wendy Parkman*

"Many of the best fliers are Americans. Mexicans, Americans, a few South Americans and a few Australians. Maybe it's part of the American character to let go and fly—it takes a certain kind of thing. The best trampolinists are Americans, too. Same kind of thing, doing tricks and being up high and flying." — *Judy Finelli*

The Pickles don't do flying trapeze—it requires two swings, and there just isn't enough room in the ring—but there is usually a trampoline act, which involves even more air-time than the trapeze.

"What interests me most about the trampoline is that it's cooperative. It's used as training for the flying trapeze, in fact. You're working with, say, two other people, and you have to have a very clear idea of where you are in time and space, where you're supposed to be and when you're supposed to be there. The success of the act is entirely dependent on the performers moment-to-moment awareness of each other.

"The other intriguing thing about the tramp is what a child-like pleasure it is. It's just like bouncing on your bed. It's a great piece of apparatus."
— *Larry Pisoni*

Next to the trapeze, which in many ways is still the ultimate circus experience, probably the most memorable aerial act is wire-walking. The Pickles have had several wire and rope walkers (Johnny Ryan, Sando Counts and Marc Jondall), each with different perceptions of the nature of the craft. Here's one version:

"When you're on the rope, there's really a lot of surface area to stand on, your foot curves around and touches a lot of rope. But your foot doesn't curve

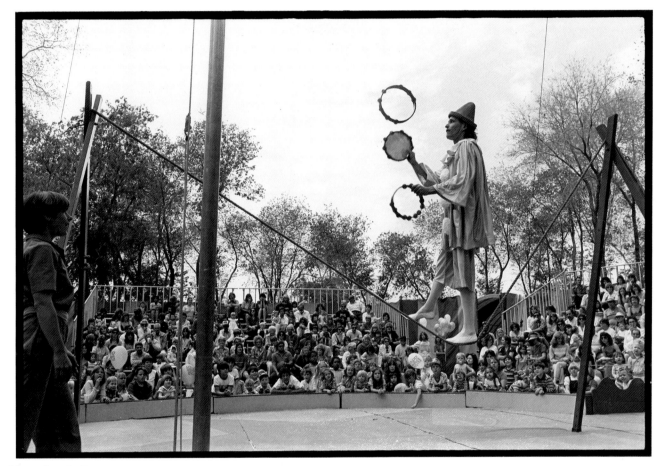

Marc Jondall

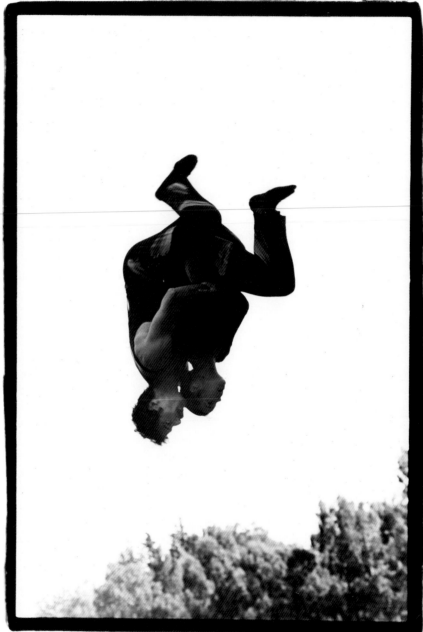

Billy Kessler and
Rebecca Perez

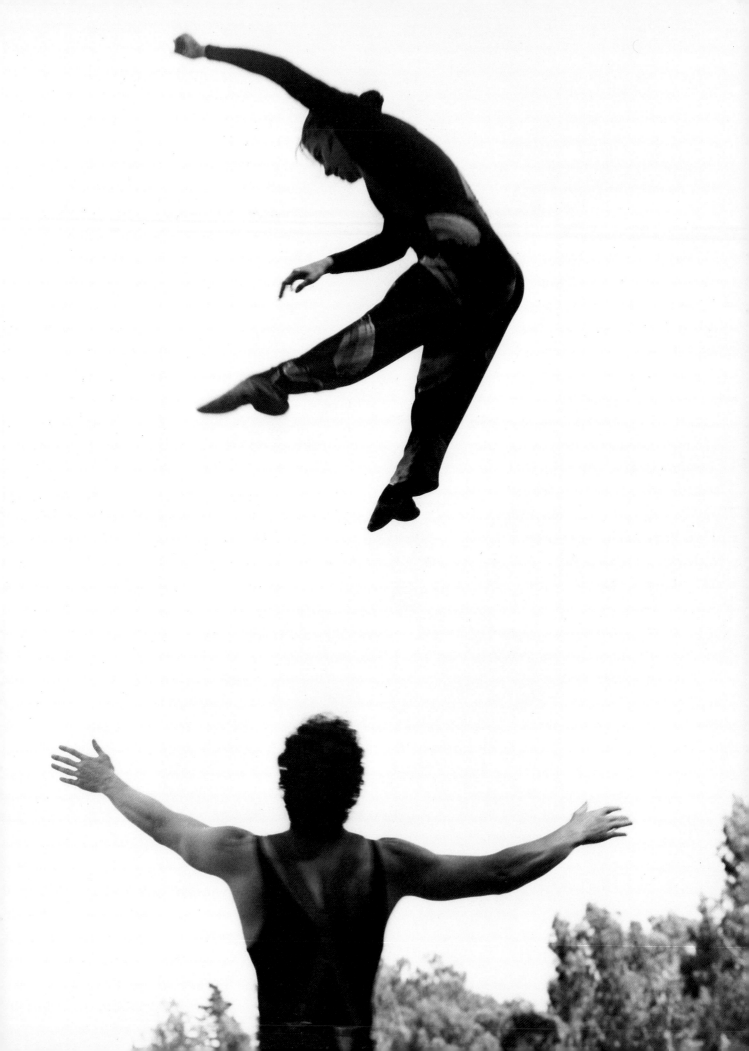

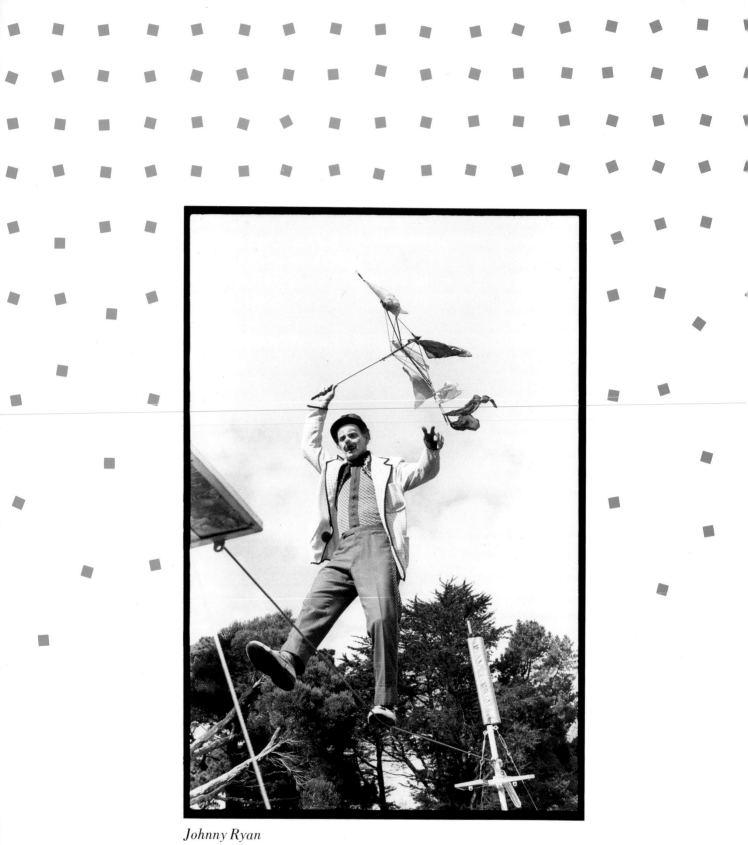

Johnny Ryan

that much, and when it tries to keep curving…well, that's why people are shaky on the rope at first. And that's why the slack rope is so much harder than the tight wire; the slack rope just accentuates that shakiness. It makes your foot muscles that much more nervous. Standing on a tight wire is like standing on a rock.

"I had a sort of medium slack rope; I had to experiment for a long time before I knew what kind of tension I wanted. I experimented with wire for a while, but I really like rope—I used three-quarter inch hemp—it has something of the resonating qualities of a musical instrument. And I experimented with footwear forever; first I tried ballet slippers, which I didn't like because they weren't flexible enough on the bottom; then I went to custom-made moccasins, but I went through a lot of them and it just got too expensive.

"I finally settled on plain old nylon socks. I could feel the rope through them very well, and they let me slide on the rope. I used to buy them in big plastic bags at the supermarket. Basically, they wear like iron; it's incredible. After the end of the world, the only two things around will be cockroaches and nylon socks.

"There's one great secret of wire-walking, and I'll tell you what it is: Keep your ass over the rope. That was always my rule; that was always what I thought about first, last and always. Keep your ass over the rope. There's a trick I did that looks pretty easy, but it isn't, sitting on a chair on the rope. It's a very, very hard balance. And the secret is…well, you know.

"Performing on the wire is very intense; there are so many things to be aware of simultaneously. There's your program; the order of the tricks. There are variables like the wind and the heat. There's watching the band and making sure we're all together. And there's checking out the audience; there are hot spots and cold spots in the audience, almost like temperature differences, and I'd want to play to the cold spots to warm them up.

"And there's keeping the fluidity. I really tried to get away from the old circus trick mentality, that triad: here I am, this is what I do, aren't I fabulous! Ta-Dah! That's so boring compared to what a really unified show can produce.

"But the greatest pleasure of working on the rope is how much like flying it is. I have flying dreams every night. I crawl into bed and say good-night to my body and lift my arms and fly into dreamland. In the Circus I got to be Peter Pan, complete with my pal Wendy. For me, the Circus is a Never-Never Land where dreams are born and you can be forever young."
— *Sando Counts*

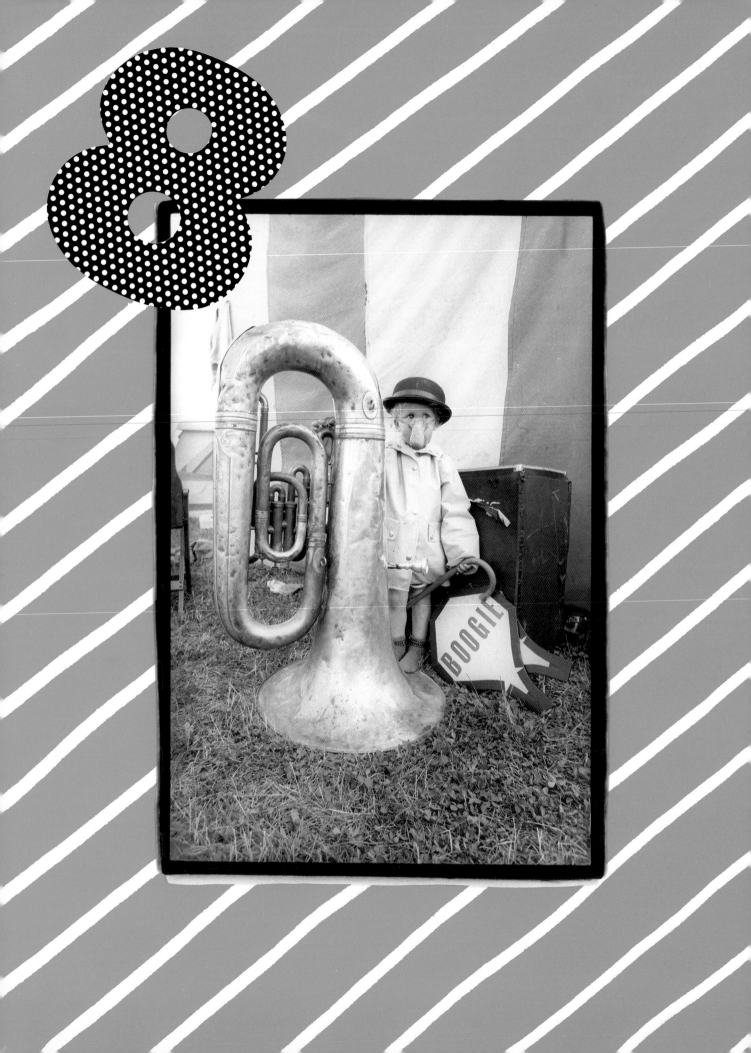

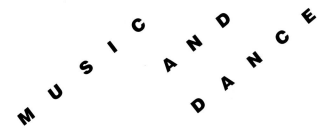

"In a lot of other circuses, musicians will just sit down and play through a book of tunes. There's no real sense of the contours of the show—sometimes a tune will just stop in the middle of a phrase and then there'll be a fanfare, The End. With our Circus, everything is carefully selected and composed; sometimes—not often—the action is even edited to fit the music. It's all integrated.

"For me, the Circus is a very unusual place where I can play jazz music. It's been this miracle that I fell into."
— *Harvey Robb*

Presenting, from high atop almost anywhere, for your listening and clapping pleasure, the unique Pickle Family Circus Band, pre-eminent in the field they invented. There isn't another band in the world that plays for a circus most of the year; there isn't another circus in the world that travels with a real jazz band, or that wants to.

People who come to a Pickle performance go away talking about the jugglers and the clowns, but the same acts performed in absolute silence wouldn't have the same impact. The music tells the audience when to laugh, and when to get rowdy, and when to pay attention. It highlights; it emphasizes; it tells its own jokes and sings its own songs. It turns the Circus into one long dance.

The size of the band varies within predictable limits; at last count there were five members (trumpet and saxophone plus the rhythm section: piano, bass and drums); there's been some talk of adding a guitar or trombone. A few of the opening tunes are by composers like Fats Waller and Herbie Hancock, but all of the music in the show itself is written, specifically for a given act, by band members.

"I've talked with all the major Pickle composers before me—Randy Craig and Mark Kennedy and Michael Margulis and Phil Marsh—and I think I understand the process. You have to develop a very flexible style of composing, so that you have sections that can be repeated and sections that don't necessarily follow each other.

"For instance, in a juggling act, if someone drops a club, there are two things that can happen. One is, we keep playing and they catch up. The other is, we vamp, meaning that we just hang on to one bar until the jugglers are ready to do the trick that fits in with the next section of music. Someone in the band calls it, and on we go.

"It's often impossible to have a final version of the music, or even a very worked-out version, because the acts aren't finished by the time the music has to be composed. I find myself more and more working with images of the type of movement that will be going on. I see acrobats, and I get a meter, and after a while I realize it's a six-eight.

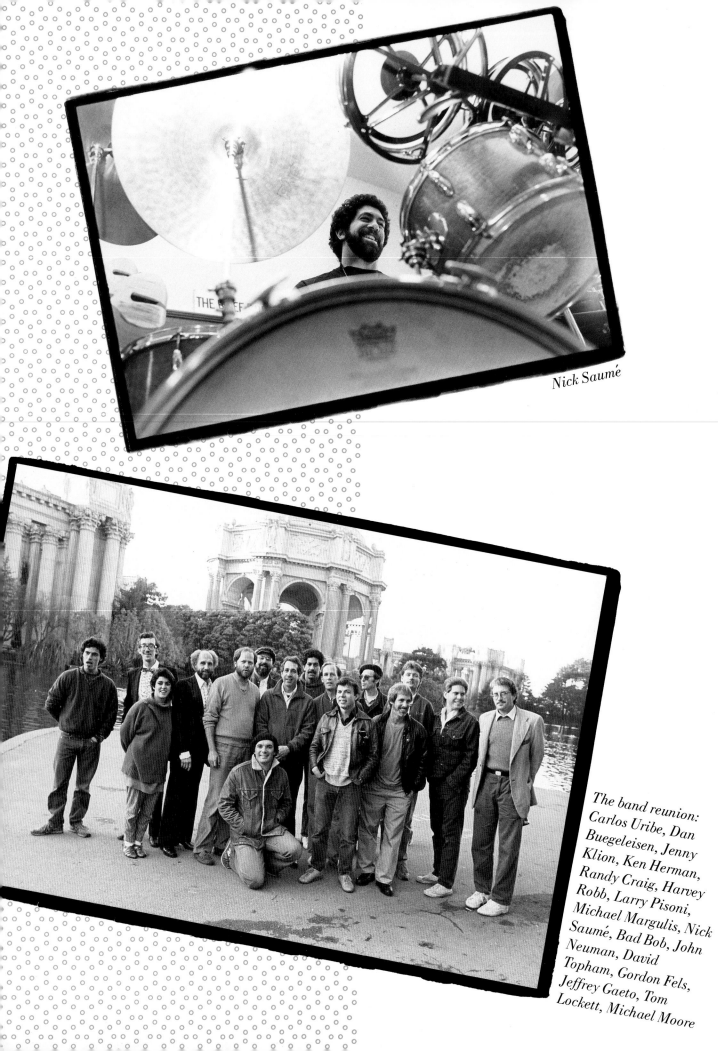

Nick Saumé

The band reunion: Carlos Uribe, Dan Buegeleisen, Jenny Klion, Ken Herman, Randy Craig, Harvey Robb, Larry Pisoni, Michael Margulis, Nick Saumé, Bad Bob, John Neuman, David Topham, Gordon Fels, Jeffrey Gaeto, Tom Lockett, Michael Moore

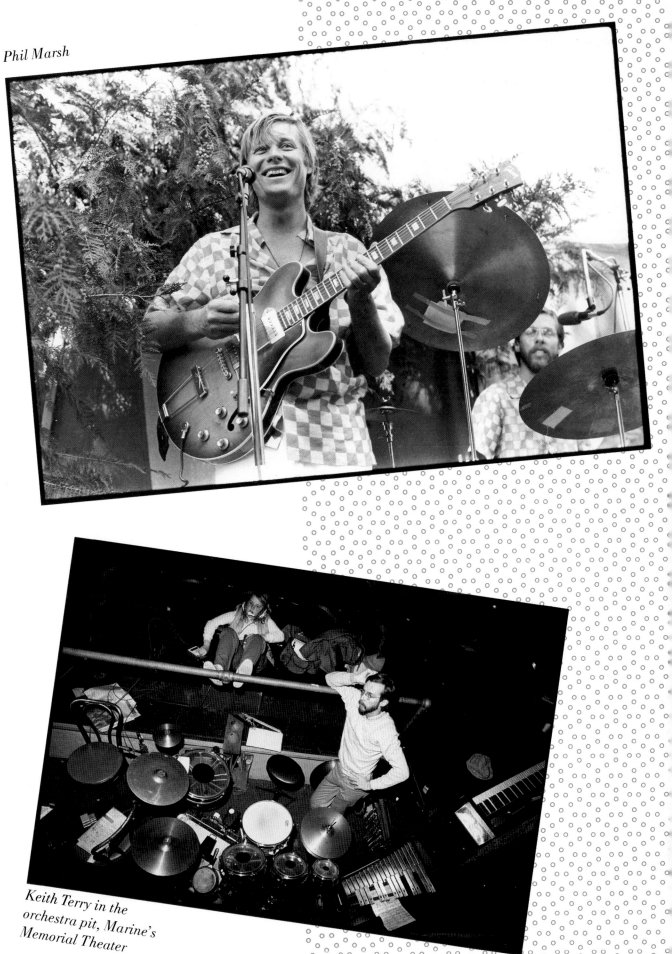

Phil Marsh

Keith Terry in the
orchestra pit, Marine's
Memorial Theater

97

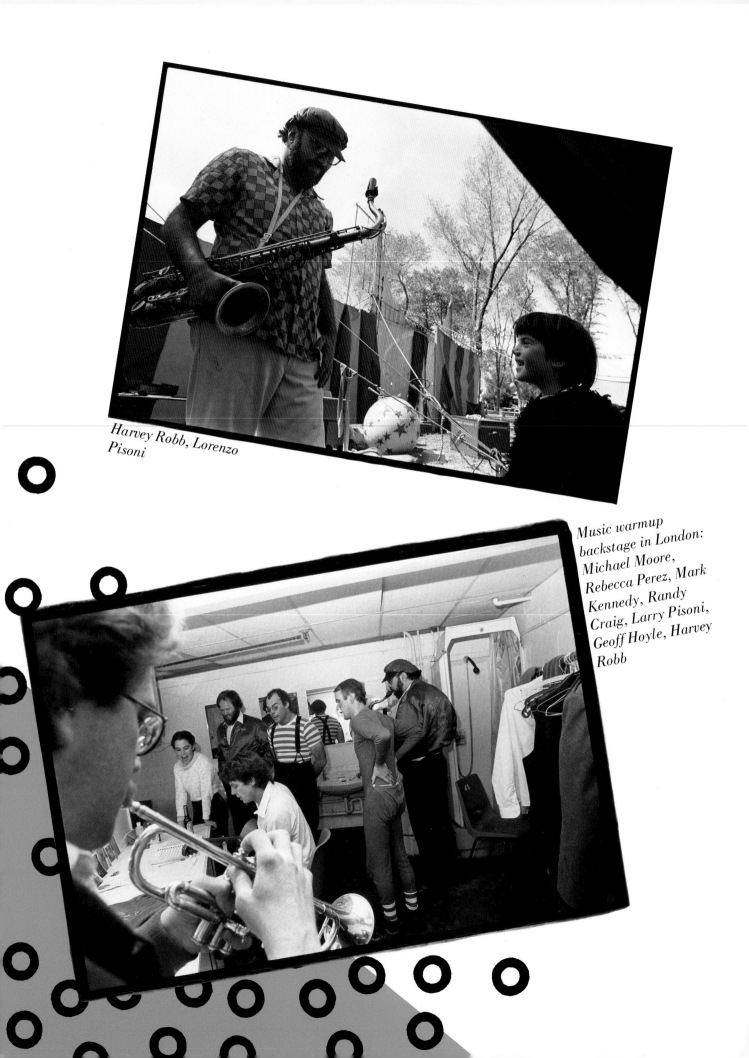

Harvey Robb, Lorenzo
Pisoni

Music warmup
backstage in London:
Michael Moore,
Rebecca Perez, Mark
Kennedy, Randy
Craig, Larry Pisoni,
Geoff Hoyle, Harvey
Robb

"Traditionally, trapeze is a three-four time, waltz time, but we've been trying to break that up a bit, to use four-four some of the time and save the three-four for when the trapeze actually starts to swing. Lorenzo Pickle was *always* in four-four; he's got that four-four walk.

"There's a lot of improvisation. Quite often, it's like everyone is soloing at once. I remember a clown act that Larry did, and Mark Kennedy wrote a piece of music for it called '30's Party Theme'. I was handed a piece of paper with eight bars on it with the chord names, and that was it. After a while, a lot of the music in the show becomes a sort of group composition."

— *Jeffrey Gaeto*

"I hated circuses when I was a kid. They scared me to death. All those clowns with that weird makeup; it was very intimidating. So my idea in writing the songs for the show was to make everyone, especially the little kids, feel welcome, to tell them that there was nothing in here that was going to hurt them. Almost like they were coming into our home, which in a way they were.

"I wrote a few weird tunes, like Mr. Sniff's theme, which was an attempt at a sort of Brechtian cartoon music, but mostly I just tried to lay down a nice solid groove without too many curve balls. Keep it light and keep it rocking."

— *Phil Marsh*

"What I really enjoyed about playing in the Pickle Band was learning about the literal translation of movement into sound. It was a strange left brain/right brain kind of thing. I'd be playing a tune with one part of my brain, while another part was watching what was going on so that I could punctuate it. And the punctuation might be completely different, in time and pulse, with the music I was playing. It's a very hard thing to get right, but once you learn it, it opens up a lot of possibilities."

— *Keith Terry*

"As the drummer and all-around percussionist for the PFC, I was the voice of all the action in the ring. Not only was I playing the intricate time changes and rhythms with the band, I was also sounding sirens, tooting duck calls, blowing police whistles and possibly giving a drum roll at the same time. It was a great challenge to be totally engrossed in the music and the acts at the same time. Without the percussion, the acts would have seemed like a mime show. It feels good to say that I was 'The Voice of the Circus'."

— *Nick Saumé*

"Once when we had someone sub for Nick on drums, he naturally missed percussing some of the effects. A performer would do a fall and there would be no sound! It was as if the person had not fallen at all. I had been in the band three years, and it was only at that moment that I realized how important the visual/audio relationship was."

— *Michael Moore*

The band also works outside gigs, and it supplements its income on the road by playing clubs after the Circus tasks are finished for the evening.

"One of the things we look for when we're auditioning new members is whether they'll be able to handle the life, and whether we'll be able to handle them. You're together all the time; people can get pretty weird in that sort of situation.

"A typical day starts at seven in the morning. We set up, we do two shows, we pack the stuff in a truck and go play a nightclub and get home at two a.m., maybe, and crawl into our tents and get up at seven again. You have

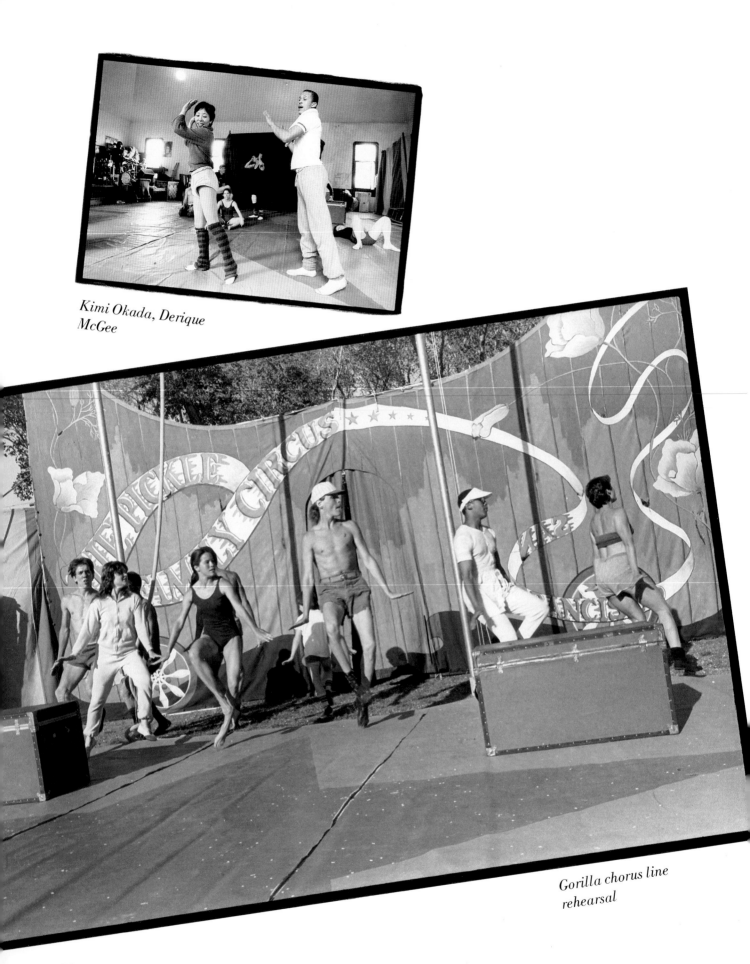

Kimi Okada, Derique
McGee

Gorilla chorus line
rehearsal

Not exactly together: The gorilla rehearsal continues

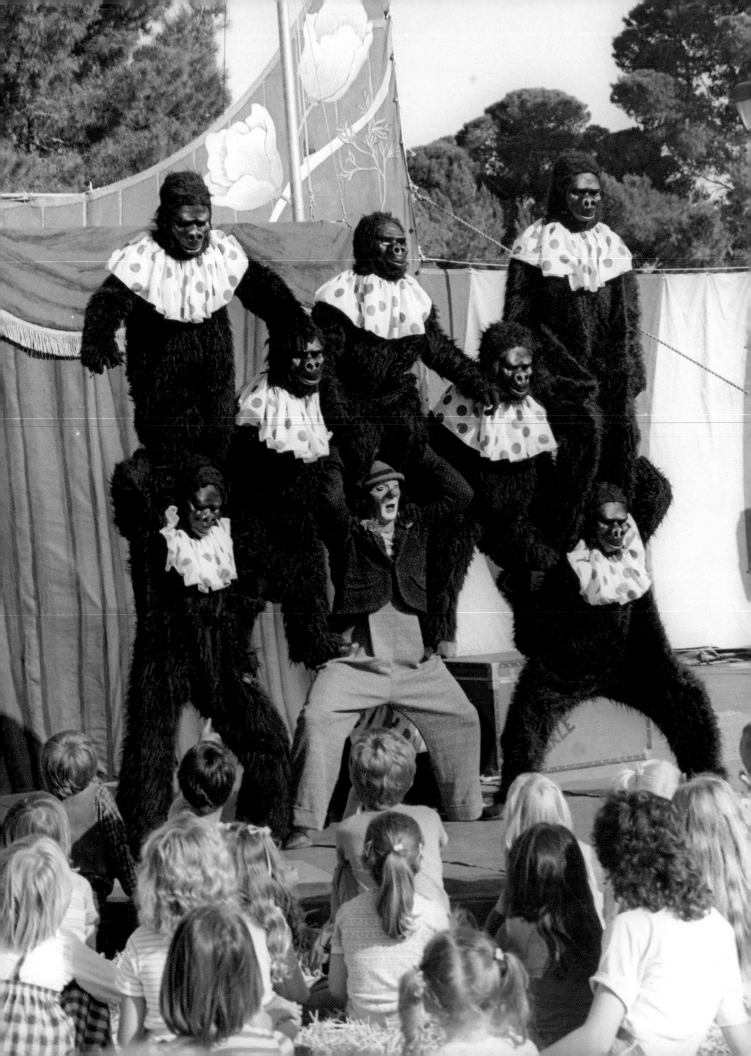

to have a pretty high strange quotient to enjoy that."
— *Harvey Robb*

"But that schedule really does help make the band a stronger entity. We've developed a reputation now in the towns we visit, so we work pretty steadily, and we have a whole different repertoire, dance music and jazz concerts. We play a *lot* together. And the communication after a year is amazing."
— *Jeffrey Gaeto*

Top row: Michael Ohta, Rebecca Perez, Robin Hood. Second row. Judy Finelli, Zoë Leader. Third row: Derique McGee, Larry Pisoni, Jay Laverdure.

The PFC involvement with Music is continuous and serious. The PFC involvement with Dance is sporadic and primarily concerns tap dancing gorillas. The Original, Genuine Tap Dancing Gorilla, later Choreographer to the Gorilla Chorus Line, steps to the microphone to tell us all about it:

"Being in the Circus was really my first brush with doing popular entertainment. I'd been a modern dancer all my life, and suddenly I had to get into a gorilla suit; it was the hardest thing I'd ever had to do. Everything in my training had taught me to be pure and abstract, the essence of emotive modern dance. The big no-no's were anything literal, narrative and theatrical. And yet there I was with Willy doing this skit as a gorilla that wants to tap dance.

"So, of course, with my dancer, scholarly approach, I went to the zoo and watched gorillas. How else would I do it? I don't know how much that helped, actually—I was scared to death the first time I had to put on the suit and dance for Larry. But I did it. It was my first paid job as a dancer in California. Little did I know that eight years later, I'd be choreographing a dance for nine gorillas in the PFC.

"I don't do formal notation for my choreography, I just learn it myself and teach it to other people. With the nine gorillas, I wanted sort of a flapper effect, very Twenties jazz age feeling. In choreographing for gorillas, you can't do anything subtle because the costumes are so bulky, no winks or finger movements or anything. The gorillas were a huge hit, it turned out. Kids loved it, because it was a scary animal that started doing the unscariest thing imaginable, a silly little dance."
— *Kimi Okada*

Often, the not-so-scary-anymore dancing ape would move into the audience, steal popcorn, pry inside handbags, act rude, introduce chaos. The benign side of unpredictable confusion was introduced; the delights of irrationality were demonstrated.

Which is one of the great seductive elements of dance. The doing before the thinking; the doing beyond the thinking.

Was that your banana?

Thank you.

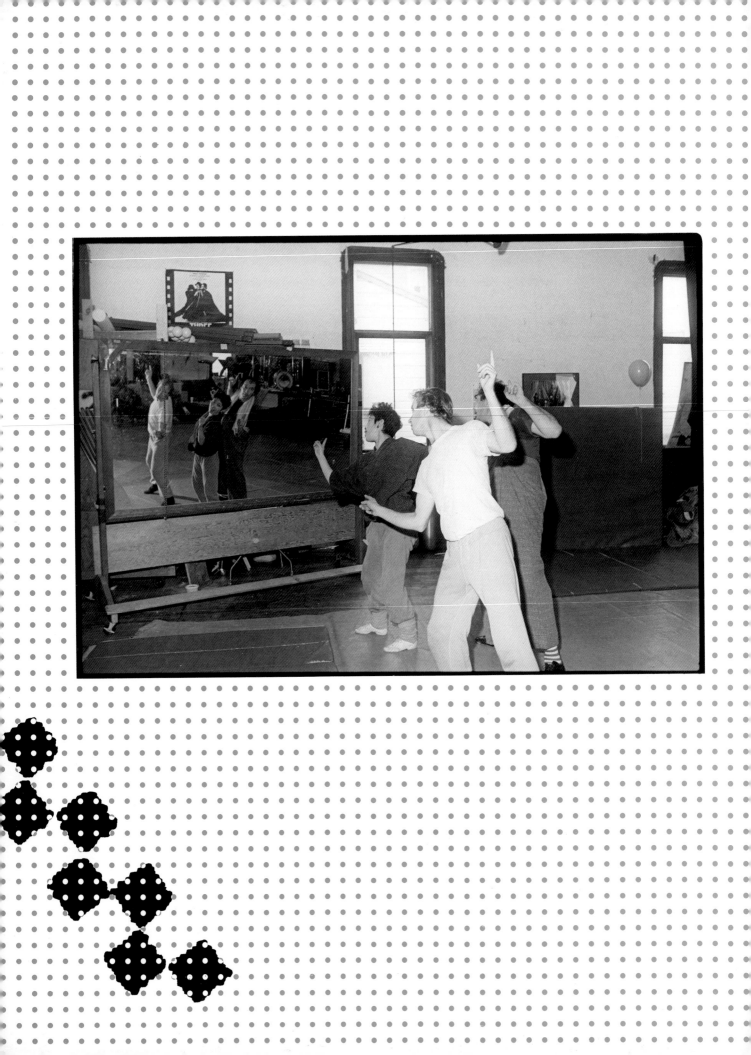

*(left) Kimi Okada
choreographs a dance
for Geoff and Larry
that (right) resulted in
horned-hat silliness*

Some attractions (like Disneyland, or the cathedral at Chartres) can stay in one place, but a circus has to move to find its audience. This has been true for so long that the idea of circus has become inextricably intertwined with the idea of travel. A circus is rooted in rootlessness; it's part of the romance, part of the mystery.

It's a fantasy, of course, but a very persistent and attractive fantasy. The merry band of gypsies; the special brotherhood of necromancers; world travelers; children of the wind. The circus universe is mobile, all energy and flash and laughs and see ya next year. Who was that masked clown? I dunno, but he left this silver slapstick. It's a way of living in society without being part of society; it's also a way of creating a new society while seeing a lot more of the old one.

People, after all, don't join the circus to stay at home; people join the circus to run away.

"One of the things that was satisfying about touring with the Pickles was the immediate rapport we seemed to have in all these places, because we were part of an organization that they knew and trusted and accepted. It was, for me, a whole new way of thinking about touring. I've done a lot of urban touring, where you go into a city and do a show and then you're gone. But with the Pickles, I have vivid memories of going into someplace like Bandon, Oregon, and the people would just open the town up to us. They'd give us discounts in their stores because they'd recognize us as being from the Circus.

"There was something wonderful about it that reminded me of the traveling shows of 100 years ago. Groups would go from village to village not only entertaining but also passing on information. I like that feeling a lot. Wherever you go, you're taking along information about the place you've just been and contributing to an exchange, to a flow of ideas."
— *Keith Terry*

"The adverse conditions on the road were really part of the good times, somehow. After a few years with the Pickles, I felt like I could do a gig hanging from a tree in a hurricane. Really. I can do a show anytime, anywhere. It may not be great, but it will definitely be a show. If you can get a show done, maybe you can get your life done."
— *Randy Craig*

The Pickle Family Circus started seriously touring in 1976, five glorious weekends in Northern California: Ukiah, Fort Bragg, Chico, Arcata and Santa Rosa, plus a mini show in Ferndale that had to be timed to fit with the farmers' milking schedule. During the weekdays, the Circus would find some exquisite camp site or pastoral swimming hole and do nothing with great intensity.

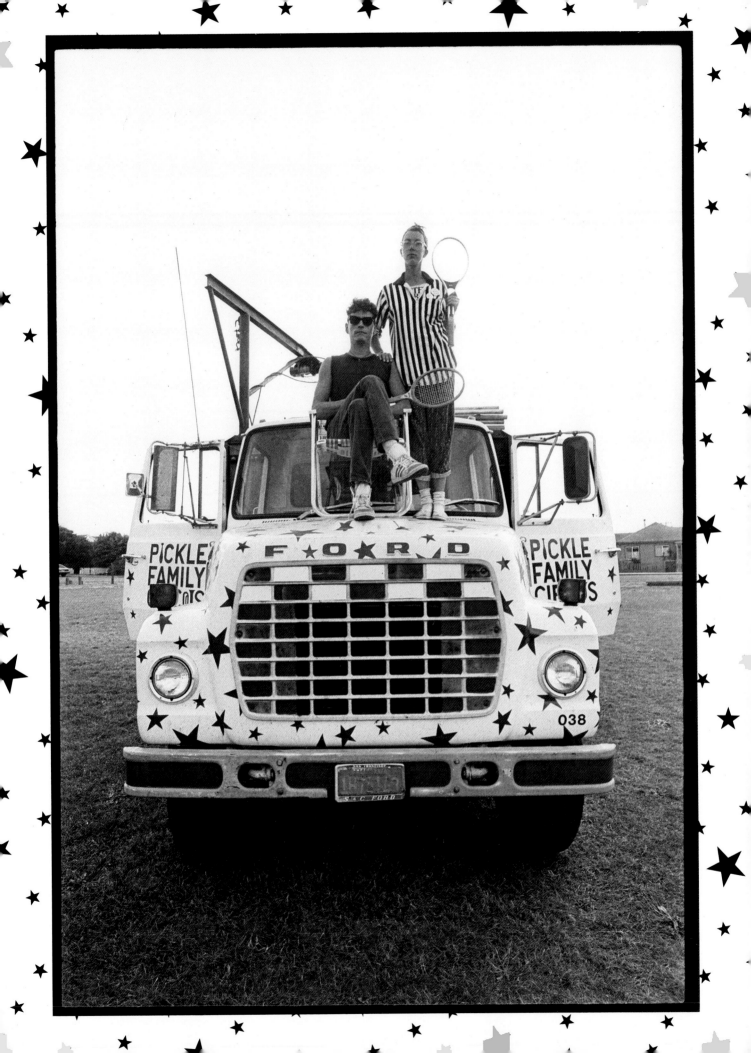

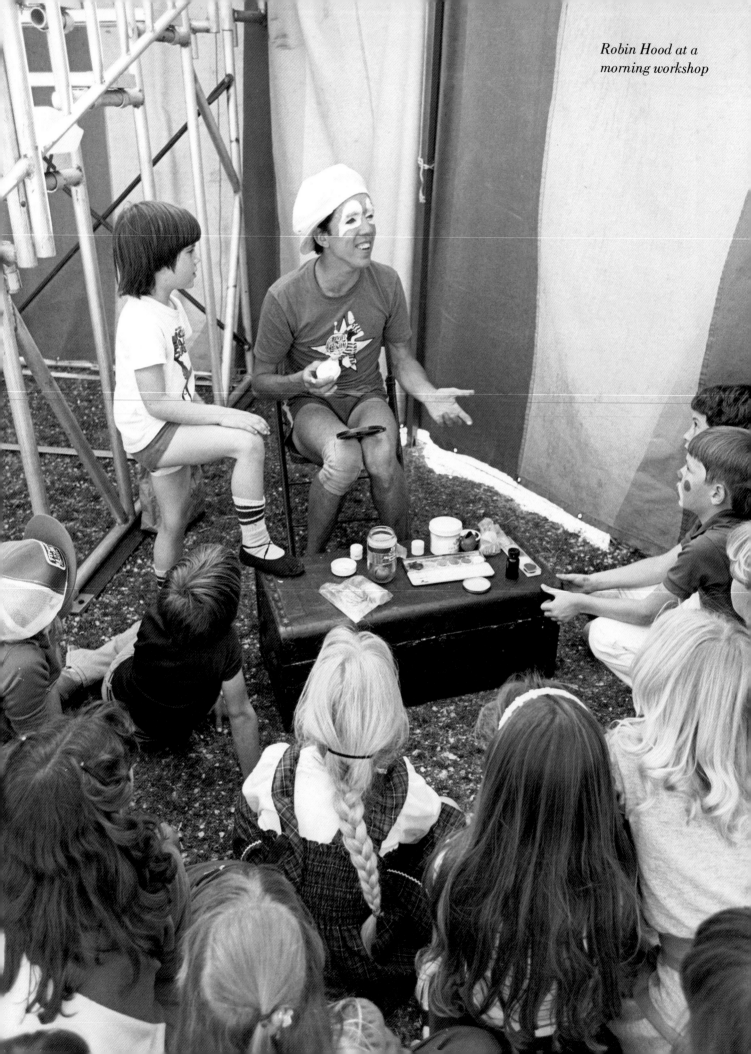

*Robin Hood at a
morning workshop*

Geoff Hoyle and friends,
backstage in Pasadena,
California

Each year thereafter the tour expanded, mostly into Oregon and Washington, with more stops in Northern and Central California. Along the way, there was a trip to Alaska; a few forays into Southern California, Arizona, Nevada and Colorado; and six weeks in London during Christmas of 1981.

The procedure for every tour (except London and Alaska) was more or less the same, easy to describe, hard to execute. After the Pickle bookers had arranged the schedule (the Circus was always sponsored by a local community group with whom it split the proceeds of the show; for details, see Chapter 5, "The Shadow of the Pickle"), everything—people, costumes, bleachers, equipment, amenities, personal objects of great meaning—was packed into several trucks, engines were started, gears were engaged, right at the on-ramp, left at the Interstate, hello Frisco goodbye.

Miracle in Alaska: Billy Kessler with broom handle and balky transmission part

"Probably the most famous Pickles-on-the-road story is The Tale of the Broom Handle, which everyone remembers as the ultimate in something. We were on the AlCan Highway in Canada, on our way to Alaska. In that stretch, the AlCan Highway isn't a highway; it isn't even a road. More like a fire break. The road was so bumpy we couldn't go more than 20 miles an hour, which we couldn't have done anyway because it was so dusty you couldn't see anything out the windshield.

"Did I mention it was hot? Did I mention we were miles from anywhere? Did I mention that the dust made mud between your teeth and gums? Did I mention that we were late? That's when the transmission on the truck—we had an old 1968 International five-ton truck that used to be a Sears delivery van—the transmission just ceased working. We were coasting. So we looked underneath and saw nothing, no oil leaks, nothing that looked bad, except it was completely broken.

"Eventually, we isolated the problem in the changer motor, about which we knew nothing, so we decided to get in the other car and drive until we found a farmhouse or something. Which we did, and we found this guy watching television. He got on the two-way radio and the next day this kit arrived that was supposed to fix the changer motor.

"Except the kit had nothing to do with the problem. Just some spare gaskets and replacement screws, and we had all the screws we could ever hope to have. We had figured out by then that the problem was a broken fork-like thing. In desperation, Billy had an inspiration. We got a broom from the back of the truck and sawed off the end of the handle, and wrapped a few matchbooks around it to make it thicker, and jammed it up there and, by God, drove all the rest of the way in low. With no trouble.

"So that's how to fix a transmission with just a broom handle and two matchbooks. A real Pickle special all the way."
— *Larry Pisoni*

"My favorite road story happened in the tiny town of Gold Beach, Oregon. The show had been packed the first evening, and the weather was gorgeous, it was sunset, and it was the very end of a very great show. Everybody was real happy and real quiet, in total sync. When Larry was doing his closing remarks, it was almost like a conversation between friends. He says: Now I want you to go home and tell everybody you know to come and see the Pickle Family Circus for themselves.

"And a little girl who was sitting right up by the ring yelled, 'But, this *is* everybody we know!'" — *Zoë Leader*

"Okay, we're playing in Bandon, Oregon, and our next date is Portland. This was the year that Mount St. Helens exploded, and there were reports

*Willy the Clown greets
an admirer*

that Portland was covered with ash, and no one knew what the effects of the ash and silicon would be on our lungs or our chromosomes or anything. So we had a giant debate inside the company about whether or not to cancel our date in Portland, which would have meant letting down our sponsors, the Burnside Community Council. Eventually it got real heated, as a lot of Pickle debates tended to get, with one side saying, we've never done that before, cancel a show on account of a volcano, it would be a bad precedent, and the other side saying they weren't prepared to die for the Pickle Family Circus.

"So eventually Terry and I volunteered to be an advance reconnaissance team. We drove up to Portland along the coast, turned inland, and we kept expecting to see a hugh dark cloud on the horizon and caravans of cars fleeing the city—some sort of bizarre science fiction scene. But it was lovely, really, just a little hazy, and the sunset was spectacular. There was ash, but it was mostly in the gutters. A few joggers were wearing masks, but that was it. So we played Portland, and the audience was real happy to see us."

— *Larry Pisoni*

"I remember that year. 1980. Mount St. Helens was only a part of it. It began with a couple of us deciding that we were going to book an East Coast tour. Some of the gang was over in Malta doing Robert Altman's 'Popeye,' so I thought, la-de-dah, why don't we just bop back East and just book a grand tour. Well, that was the last *truly* naive and tremendously foolish thing we did. The tour didn't materalize, but meanwhile we had pushed all our regular Northwest dates into June, so we had a July and August with virtually no work.

"So, right after Portland, we started playing all these poorly planned little dates with hardly any advance work and a bunch of rain thrown in. And then we got to San Juan Bautista right around the time there was an earth-quake in Hollister, which is just down the road, and along about that time Geoff Hoyle started promoting the idea of Pickle Disaster Tour 1981. You know, Biafra and Bangladesh and Beirut and anywhere there was human misery, you'd be sure to find the Pickles. God, it was a grim time."

— *Terry Lorant*

"You've got to keep your sense of humor on the road. If you can't see the funny side of things, one night you'll just take off all your clothes and run screaming into the night. Of course, that happened once too. And it was pretty funny." — *Nick Saumé*

"We were once in Modesto, set up on a site where you could see the weather coming from miles in any direction. It was touch-and-go from the beginning. We set up the show in a mild drizzle, but the real rain held off and the first half of the show went just fine. We start the second half, the trampo-line goes great, and we're into my act with Lorenzo, where Lorenzo plays a puppet that comes to life. He starts the act in the trunk.

"So I'm trying to keep my mind on my job, and I look out past the main bank of bleachers and I see it. I mean, Weather. I knew it was going to hit any second. So I went out of character and said, 'Ladies and gentlemen, we're going to have to call this performance because of the bad weather we're about to experience.'

"And no sooner had I said that than the worst possible hail storm just opened up, just buckets of golf balls coming down on the aluminum bleach-ers—it was very noisy—and the audience just racing off, a thousand people scrambling for their cars, and everybody backstage trying to cover things and put equipment in the truck; just general madness, and pretty scary.

Under the volcano:
Peggy Snider, Randy
Craig and Zoë Leader in
Portland, Oregon

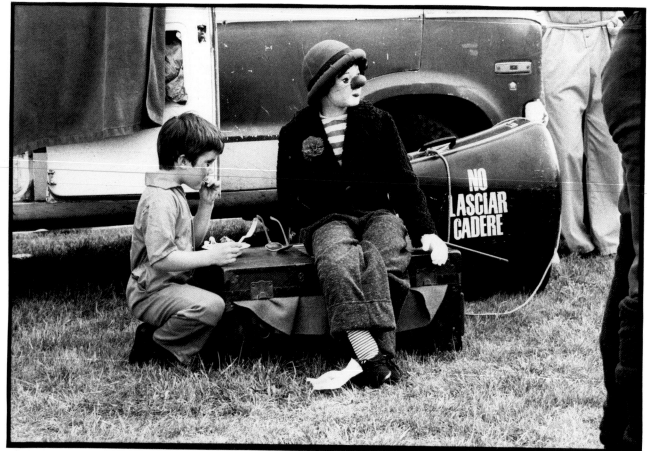

Lorenzo Pisoni with the
puppet of himself

At the swimming hole in
Langlois, Oregon

"Meanwhile, of course, Lorenzo's still in the trunk. I've got a puppet in my arms and Lorenzo in the trunk, and all I can think to do is grab one end of the trunk and run. So he's bouncing around in the trunk, and the hail is hitting the top, and I get near the van and let him out, and he's just laughing like crazy. He figured he was in the best possible place; he was warm and dry and he didn't have to do any work." — *Larry Pisoni*

"In 1981 we played Napa in 112 degree heat and Ashland, Oregon, in 114. Literally. That was the year of the multiple Sniffs routine. There were three of us, Wendy and Peggy and me, all dressed up like Mr. Sniff. And the way we got on-stage was that we were carried out on Larry's back in trunks, Wendy and I in one trunk and Hoyle and Peggy in the other trunk, in sort of twin fetal positions. There was not two inches of space left over when we got packed in there.

"And it was *so* hot and horrible in Napa, and we were packed in the trunks, but we never even considered saying 'forget it'. There was some intense—maybe insane—group pride that enabled us to do things that none of us individually would have ever thought of attempting.

"I think that at least half the audience was there in a state of utter disbelief—at themselves for sitting there in the first place, and then at us for actually performing in that open-air oven. We came out at intermission with a water hose and squirted down the audience, just completely soaked them. And they sat there in their fine and decent clothing and just applauded as we drenched them to the bone."

— *Terry Lorant*

The road breeds anecdotes like mayflies. They got a million of 'em, songs of triumph and disaster, tales of love and glory, the intense narratives of travel, which are inevitably hyper-realistic. Something about the world of NEXT GAS 27 MILES and VISTA POINT 500 YARDS makes all memories more memorable.

But there are other aspects as well, musings, connections, regrets.

A morning workshop in Ukiah, California

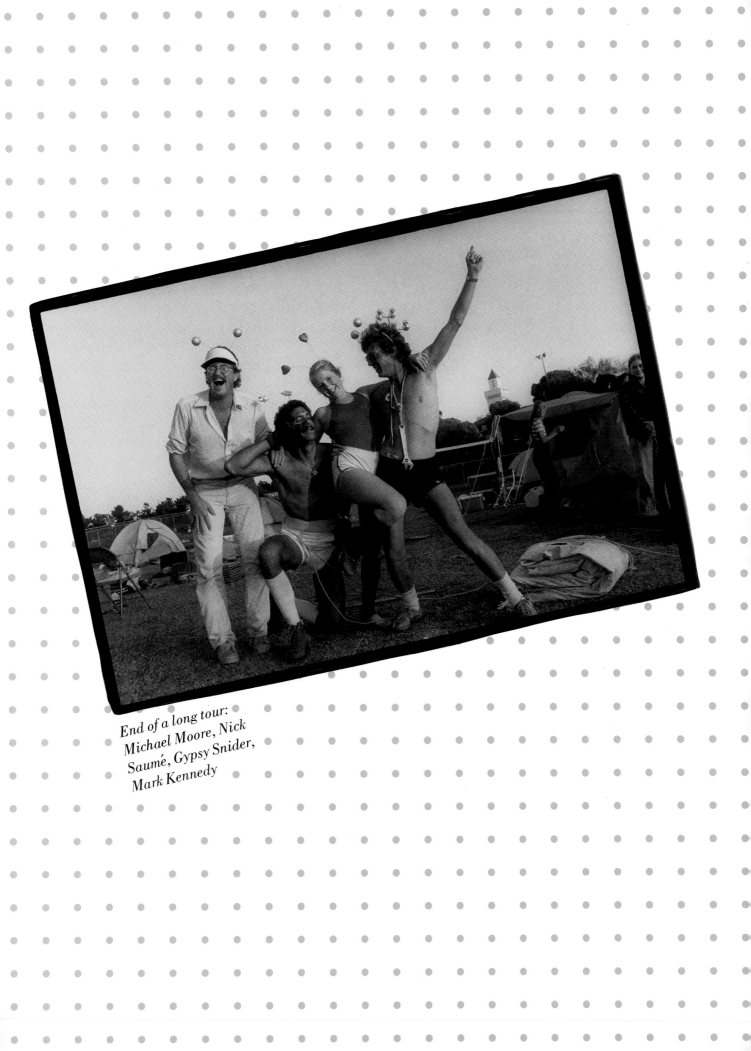

End of a long tour:
Michael Moore, Nick
Saumé, Gypsy Snider,
Mark Kennedy

"We always carried a kitchen with us, a propane oven and stove, and there was a time when we had lots of meals together in the company. But now people have developed very particular dietary habits. We have carnivores and vegetarians and people who live on nothing but pistachio nuts. So it's changed a bit, which is unfortunate, because our big meals together were always fun.

"We'd finish the first show, and during the break before the second show somebody would start a stew or a soup, and everybody would pitch in two or three bucks to cover the ingredients, and by intermission of the second show you'd see people at the table cutting vegetables and stirring the soup. I liked that a lot. Then after the show, everybody would put their props away and then finish making the meal and sit and eat it and talk about the day. I miss that. I do."

— *Larry Pisoni*

"When we did mid-week shows, the schedule was really rough. We'd arrive somewhere on a Friday afternoon and do the set-up. Saturday, we'd do two shows; Sunday, two more shows, then strike Sunday night, drive to the next place on Monday and set up Monday night for shows on Tuesday and Wednesday. Then strike Thursday, on to the next set-up on Friday.

"For a while there, we also did a workshop on Sunday mornings for people in the community. We'd introduce them to juggling and tumbling and the tight wire. The parents and kids got to try the same thing and watch each other. It was a great idea, but after a while we just couldn't hack it; we'd all be just too tired. So we cut it out.

"There's several tons of equipment, and a set-up with lights can take a good four hours, and that's with 20 healthy bodies working at a good clip. Certainly, the fact that all the performers always participate in that part of the labor has been a real unifying factor. But still, it was very hard, and injuries were very common.

"One of the things onlookers have always told us is, 'my, you all look so healthy.' And my reaction to that was always, 'yup, if I weren't so healthy I'd be dead.'"

— *Terry Lorant*

"I remember once I was asked to give a speech for a Rotary Club in Oregon, as a favor to an electrician who'd helped us connect the power. It was a town right on the ocean, so I drew a parallel between the Circus and sailing. Which is a good analogy, because all the rigging on the big tops originally came from the big sailing ships, all the bailing rings, and all the blocks, and all the canvas work, they all came off the boats. As a matter of fact, a number of king poles in some of the early circuses were just old masts.

"Even today, knot-tying is the one skill that everybody at the Circus has to learn right away. It would take twice as long to set up on the road if everybody were tying their half-assed personal knots that wouldn't stay or would take about eight hours to undo. It's funny the connections you can find when you start to look for them."

— *Larry Pisoni*

A great big ship plunging into the night, loaded with clowns and jugglers and acrobats and saxophone players. The Flying Pickles; the great ghost windjammer from another time, sails flapping, ropes flying, running down the wind. Impossibly romantic, of course. Won't happen here; much too late in the century. Still, there are legends...

Captain, do you hear anything?

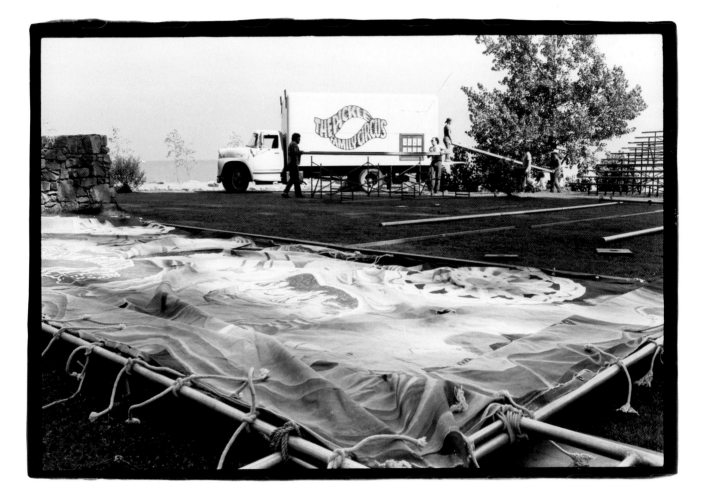

THE FAMILY IN THE MIDDLE OF THE PICKLE

We take you now to a hypothetical (but lovely) location anywhere in the Pacific Northwest. An equally hypothetical (and equally lovely) Pickle person is strolling on the grass, thinking the thoughts of the day and wondering about lunch. A member of the general public politely intercepts the person.

"Are you with the Circus?" asks the member.

"Yup," says the person.

"You know, one thing I've always wondered. Are you guys really a family?"

It's a tough question.

Lorenzo Pisoni and
Willy the Clown

"What is family? Why was it ever named family? When we first used that word, we had no idea where we were going or what it would be like when we got there. In some instinctive way, without having the remotest notion about what life backstage would be like, we knew we'd be a family.

"The whole thing, particularly when we're out on the road, is very homey. If Bad Bob snores in his tent at night, everybody knows it. If somebody has a fight, everybody feels it. If somebody is worried about their parents or their bank account or their performance in the show, everybody has an opinion. Given how we live our lives, how could it be otherwise?

"People are always asking us how we live on the road for months at a time, and the fact of the matter is that we don't travel and live in well-equipped motor homes—we all set up 'house' in a tiny 'tent city' back stage. And we cook a lot of our meals together on camping stoves and we get showers by hooking up little solar shower units under the bleachers. It's all a bit absurd when I stop to think about it. But it also really does create a certain kind of intimacy among us which I know carries over on stage. Of course, it sure would make life a hell of a lot easier if we toured with a fleet of Airstreams."
— *Peggy Snider*

"I believe everybody is seeking community. It's a wonderful need. The Circus is its own community; if you're looking for that, it's right here. That's very profound; most people never experience it at all. When you go on the road and see what most people's lives are like...there's a lot of lonely people out there. There are a lot of people with no family and no community.

"I remember the feeling I got saying, 'I belong to the Pickle Family Circus.' I was very proud. The pride didn't have anything to do with whether we had a good show all the time, because sometimes we didn't. It meant that I was part of something worth developing, something worth caring about."
— *Michael Margulis*

So our hypothetical person has an answer for the hypothetical questioner. The Pickle Family Circus is a family only in some pleasantly cosmic sense, the way people who live in the same dormitory together become a

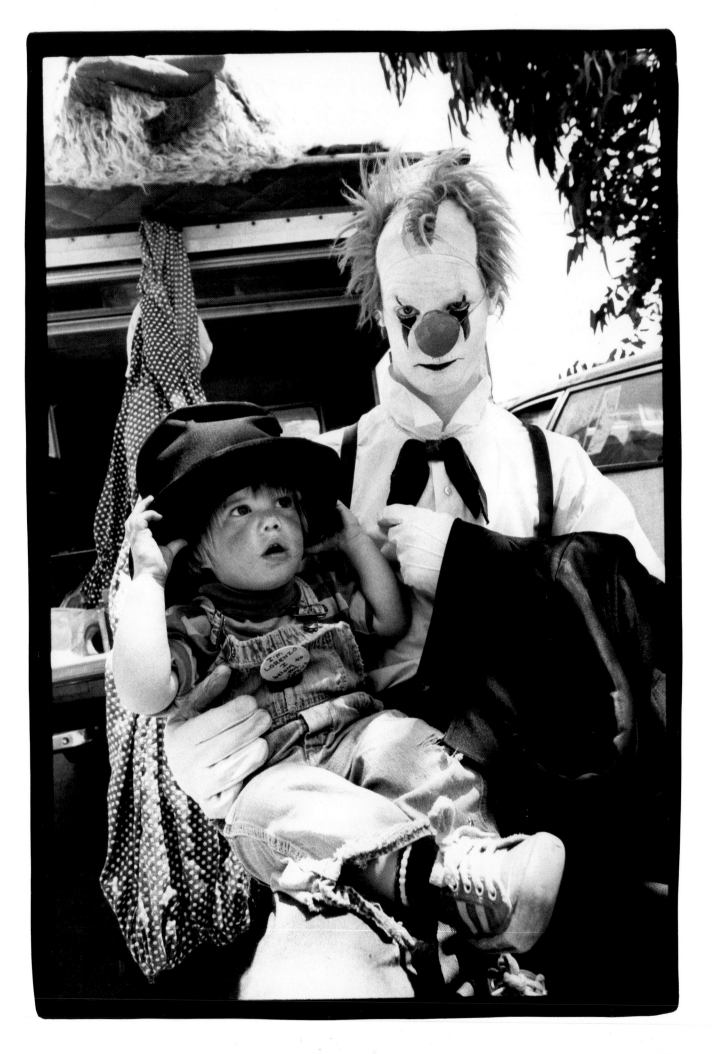

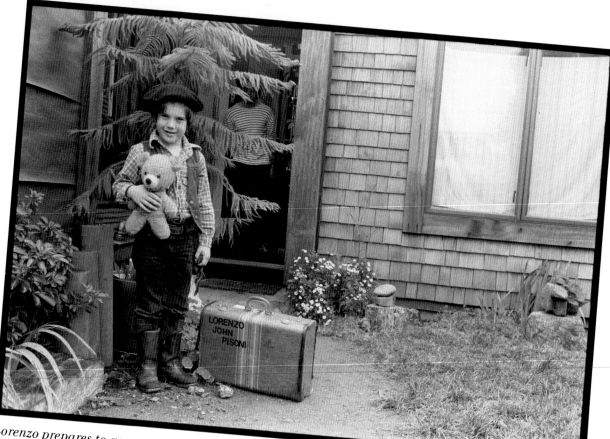

*Lorenzo prepares to go
on the road*

*Jonah Hoyle with Wendy
Parkman, backstage at
the Round House, London*

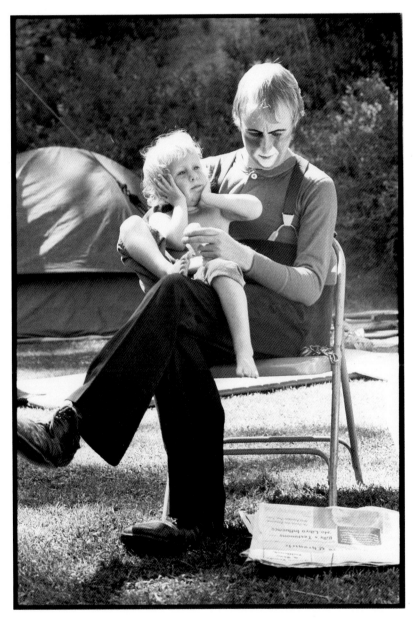

Jonah Hoyle and Geoff
Hoyle

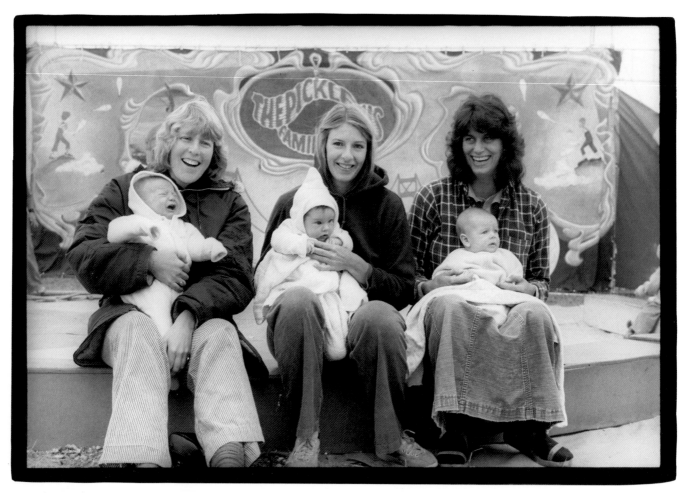

family, the way people who work for a specific political cause think of themselves as a family.

The intimacy adds amusement and texture to the experience; the bonds formed work nicely with the overall politics of the Circus. True?

Yes, but incomplete. It's not just a bunch of adults forming a mobile community around an entertainment event. There are children, too. Gypsy Snider; Lorenzo Pisoni; Jonah Hoyle; Jeff, Kelly and Shannon Weller; Melinda Marsh—all performed with the Circus at one time or another. Another dozen or so, toddlers to teenagers, traveled with the group. In one halcyon year, 1979, three babies (Lily Marsh, Miles Kennedy and Jesse Olsen) were born to Pickle members; their fathers were all band members—not a bad average for a small combo.

And when the generational stew starts bubbling; when you've got fathers (step or biological) and mothers (step or biological) engaged in the great adventure of nurture; when you've got sons and daughters and nieces and nephews and brothers and sisters all backstage, hanging in there or bored with hanging in there, clinging to surrogate parents or demanding real parents, in the ring or hating the ring; then you've got a family with a capital F.

Above: Cecil MacKinnon, Laurie Cohen, Laurie Olsen. Below: Laurie Olsen with Jesse; Cecil MacKinnon with Lily; Laurie Cohen with Miles

"Kids at the show always first ask how old I am. And then they ask, how did you get into it? And I kinda show off and say, well, my step-dad owns it. And they ask if it's fun and I say, yeah, but it's a *lot* of work. Which is true. I always hated it when it was work.

"And they would always want to know if I got out of school, but I always tell them I have to go to school. I miss a week or two sometimes, but that's okay with me. I have two very good friends, Katie and Sophie, who travel with the Mime Troupe, and we talk about it a lot. We think it's a really great thing; we feel like we're different." — *Gypsy Snider*

"When I first met Peggy and Gypsy at the Mime Troupe, one of the things I just loved was that here was this baby growing up where her mother was working, and I was part of that—I met Gypsy when she was six months old. She was in the thick of everything and many adults cared for her—nobody thought twice about picking her up or changing her diapers or feeding her when she was hungry. And I looked at that situation and I thought, 'what a lucky kid'!

"I like having kids around. I like the fact that they know what their parents do. Most of all, I like the fact that they've developed healthy relationships with other adults. I didn't have an opportunity to do that when I was growing up. I was terrified of adults; I certainly didn't feel that they were my friends." — *Larry Pisoni*

"The Circus obviously fills a need in my life, because I have kids whose lives revolve around the company. To have a family larger than the four of us is to have less responsibility for bringing up two kids. On the other hand, because the Circus is a family, I have a real responsibility for many more people. Striking a balance can get very strange sometimes.

"But one of the things that I always had a lot of anxiety about, whether I could bring my kids up in a way that would allow me to be close to them all the way through; that's lessened. I suppose I'm willing to work very hard in order not to have that classic war with my kids. Not that we don't have our fights, but at least I know what the fights are about. We're close in a way that I value; in a way that I don't see very much."
 — *Peggy Snider*

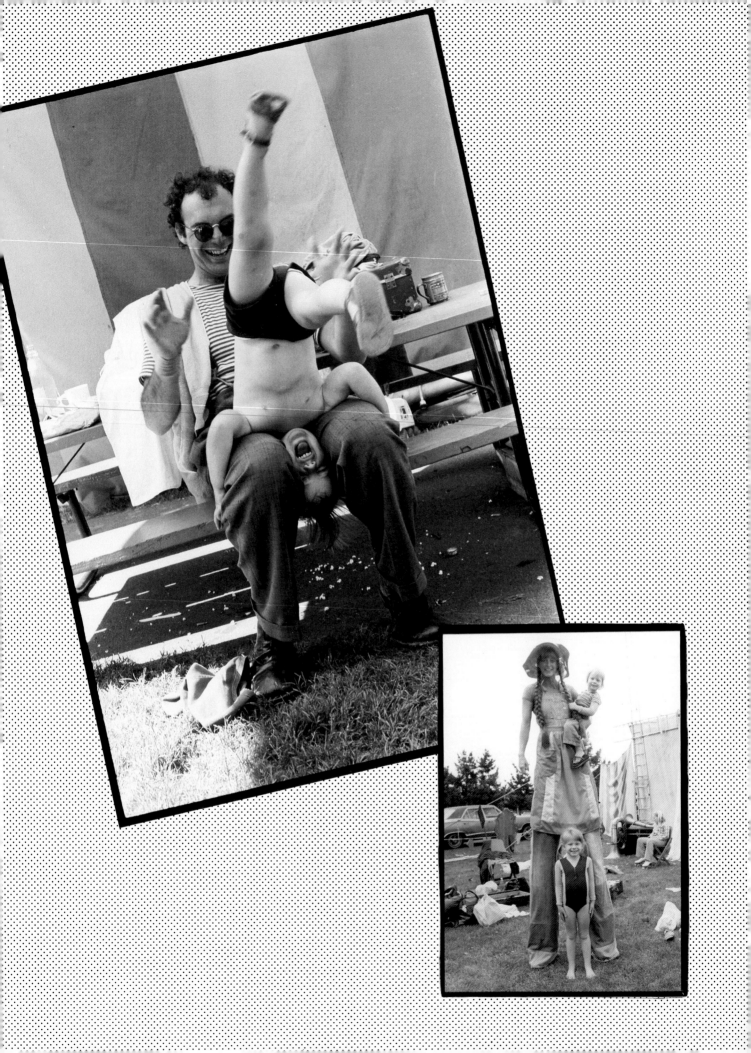

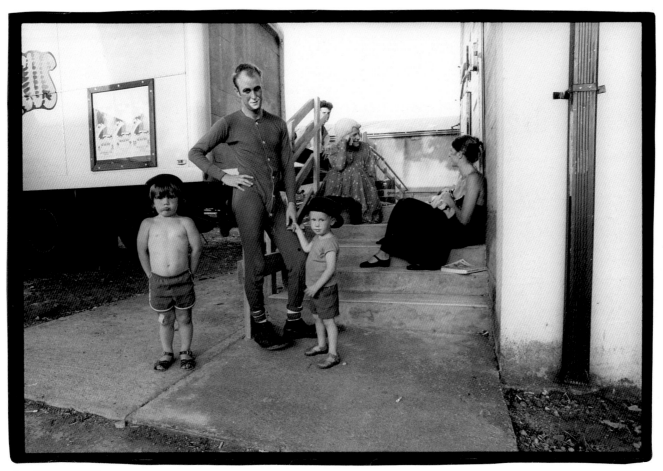

Backstage at Eugene,
Oregon

◄
Larry and Lorenzo

◄
Wendy Parkman with
Shannon and Kelly
Weller

"To me, one of the greatest missions of the Circus is to help parents raise their kids. I wasn't a father when I started working for the Circus, so when I would say rhetorically, 'fun for all ages,' it was just a slogan. Maybe part of the Circus, both for the audience and the performers, is constantly rediscovering that aspect. Fun that both adults and children really think is fun; fun that can be shared on the same level.

"To me, Willy stands out in a major way, what he represented, his shyness, his lightheartedness, his fumbling, his love of children, his love of older people. That presence was so rich. I used to make up bedtime stories about Willy for my daughter Rosy. That was what she wanted to hear."

— *Michael Nolan*

"There was a time when it seemed as though the Pickle Family Circus was the perfect job to do when you also wanted to get pregnant and have a family. I thought it was always so great, to see Peggy and Larry with their family, and they seemed to be saying, 'we're doing this because we're artists and we want to control our lives and we also want to have children; we'll have them here and they can be part of the experience and we can travel together.' To me that was so inspirational. Then, later, the touring schedule got so intense that anyone who wanted to have a baby couldn't think about that and work on the show at the same time. That was a big change. I'd love to see us go back to the way it was, at least in that respect."

— *Zoë Leader*

"As a young kid, Gypsy always stayed close by us, but Lorenzo was a wanderer. We were once playing Redway, a tiny town up north, and I decided to see how far he would roam. I followed just far enough back so he didn't notice me. He went across an entire football field and never looked back once.

"Well, given that, it was inevitable that he would get seriously lost at least once. Anyone who's ever had a wandering kid knows what I mean. So I made some buttons that said, 'If Lost, Return To The Pickle Family Circus.' I also strapped bells to his shoes. I figured, if I had to look away for a moment, at least I could hear him if he decided to take off.

"On the road, kid duties were shared by everybody. If you had to go perform, you made sure you'd hand the job off to someone else. So when you finally went to find your child, you'd have to go through an entire chain of people. Sometimes it got screwed up, but mostly it worked fine. We haven't lost a kid yet." — *Peggy Snider*

"One of the things I remember best is Lorenzo coming out and doing his Willy imitation. Willy had given him that little suitcase and hat and everything for his first or second birthday, and he got totally into it. When Willy finally came to a show, Lorenzo couldn't do it. He must have had stage fright. His mentor was there. Maybe it was because Lorenzo had stolen the best parts of Bill's material." — *Doni McMillan*

"Being a kid in the Circus is hard and rewarding at the same time. I've always had to give up summer camp, weekend sleepovers, stuff like that. Sometimes I think my age gets in the way of my work situation; I feel like people don't take me seriously. You know, Larry can come along and say, 'How do you feel about bears?' and I know I'm going to end up in a bear costume, even if I'm really not into it.

"The other hard thing about being a Circus kid is finding the line between my teenage life and being a hard worker and a good, responsible performer. It's a very unusual problem. But I've learned so much in the Circus

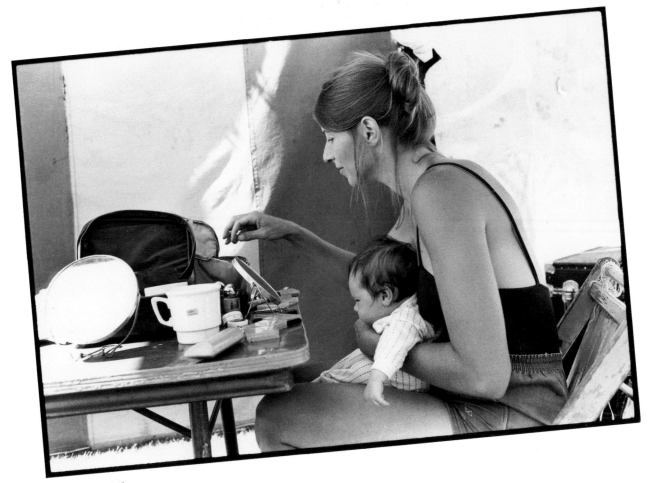

Cecil and Lily

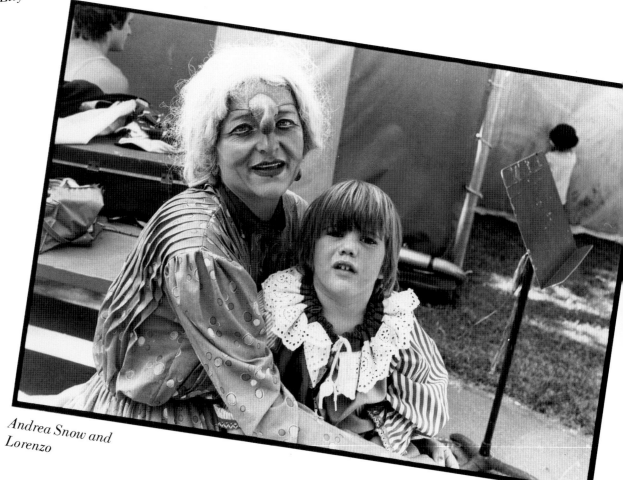

Andrea Snow and Lorenzo

about attitudes and performing and life in general, it's all worth it. I can't imagine my life without the Circus."

— *Gypsy Snider*

"We get to play at a level of discovery. We get to play at being kids. That comes out on the road a lot; doing crazy things together. Living in tents and all; it's like camp. In a way, that's the idea we want to give to the audience. There's a freedom of discovery and excitement and natural enthusiasm that we have as kids. The Circus brings that out again. As adults, we stuff it pretty far down. But every once in a while, that kid will start saying, 'let me out, let me play.' I like to think we give encouragement to that. It's all in there. Let it out. Let's play!"

— *Jeffrey Gaeto*

As part of the Pickle extended family, Laurie Olsen spent four summers traveling with the Circus as a spouse and parent. Her memories of that time are not entirely rosy.

"The experience of trying to maintain a relationship with a Pickle who was part of an intense social grouping while at the same time trying to raise an infant and be cheerful through all the strange hardships of life on the road was many times incredibly difficult and frustrating. In fact, I think that the difficulties of combining family life with Circus life were responsible for the flight of some people from the Pickles, and for very difficult periods in many relationships, including my own.

"When I think back on my time there, and on the long conversations I had with Mary Winegarden and Laurie Cohen, two other traveling spouses, I would be hard pressed to consider the Circus an ideal environment for raising kids or maintaining a relationship. I assume, though, that when both partners were involved with the Circus, it was better."

So our hypothetical person and his hypothetical interrogator are still standing on the grass, and the sun has gotten somewhat lower in the sky, and the interrogator has gotten rather more information on the subject of family than he had anticipated.

The whole notion of family relates not only to adults living in a situation of forced intimacy; it relates to communication between the generations, which is the defining aspect of actual families. Adults must be like kids in order to perform; kids must be like adults in order to perform; everybody gets inside everybody else's skin; greater understanding is achieved thereby; the family draws closer.

And is that it?

Not quite.

"What is most important to remember is that we are a chosen family. We chose each other, and we choose to be a family. We have a greater responsibility for each other, because we went into this with our eyes open.

"But what happens, I think, is that the idea of family extends even beyond the large group of Pickles past and present. It reaches out and embraces the audience, and the sponsors, and the towns that we visit. Cousin Pickle is in town. We chose each other, and now we're choosing you. We're like the crazy uncle that comes to visit once a year, and tells jokes and sings songs and does tricks. And you're always sorry when he's gone."

— *Peggy Snider*

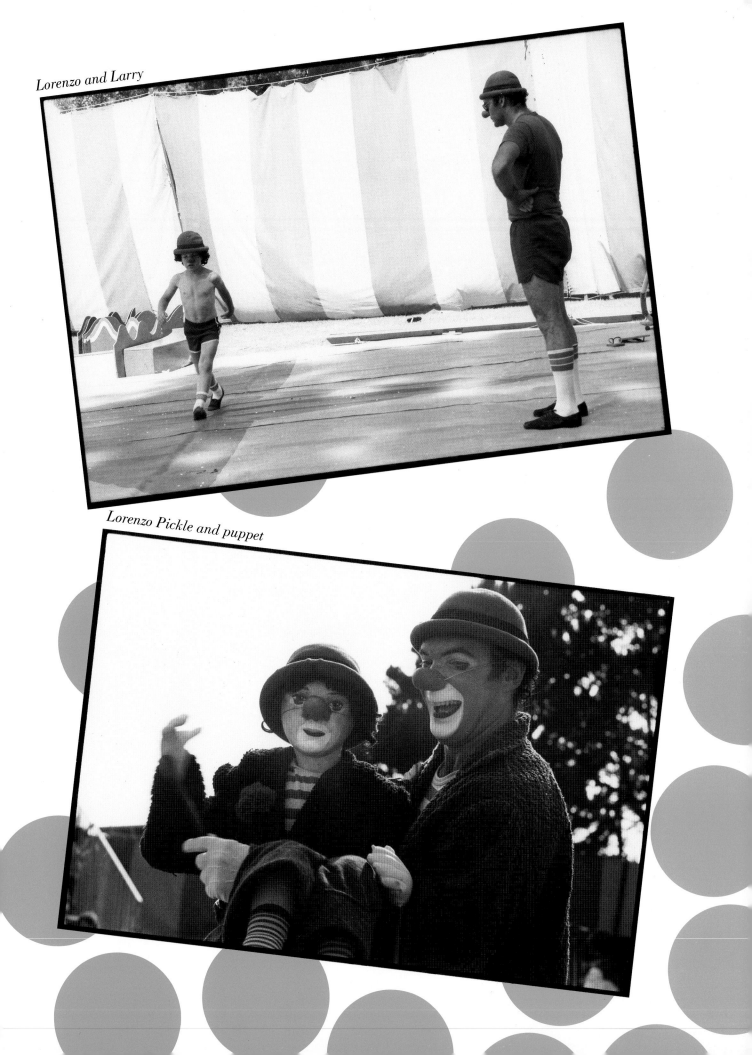

Lorenzo and Larry

Lorenzo Pickle and puppet

*Marc Jondall and
Judy Finelli*

▶

Cecil MacKinnon was a Pickle before there was a Circus, one of the original
Pickle Family Jugglers. She lives in New York now with her husband and
three children; she works as an actress; she hasn't slept in a tent in a public
park for many years. And she has some thoughts:

"There's an interesting question: What happens to a group when key
people leave? Next year, I know, there'll be virtually no one performing with
the Circus that was performing the first year. So what makes it a group? How
can completely different people be the same group?

"When we were all on the road together, the schedule kept getting more
and more gruelling; we had less and less time just to be together and regener-
ate the Pickle spirit. But the audiences kept coming, and staying, and coming
back. So something was happening, something that had to do more with the
group than with the individuals. We started out thinking we were making a
circus, and ended up thinking there was a Circus out there using us to make it.

"Something very powerful was happening. But what?"

UNTIL WE MEET AGAIN...

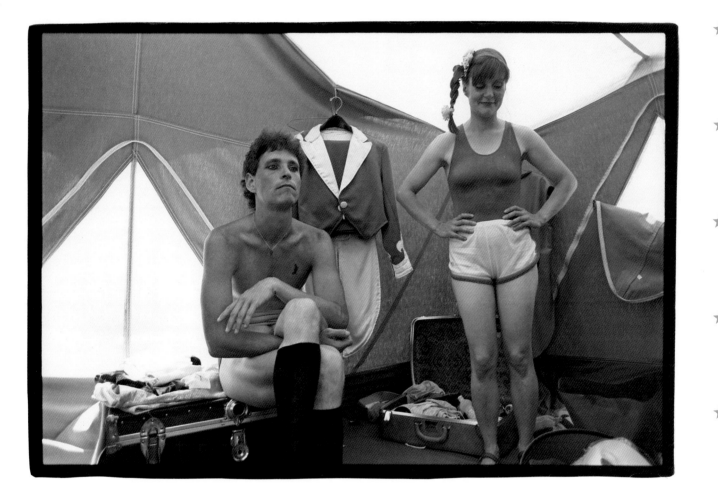

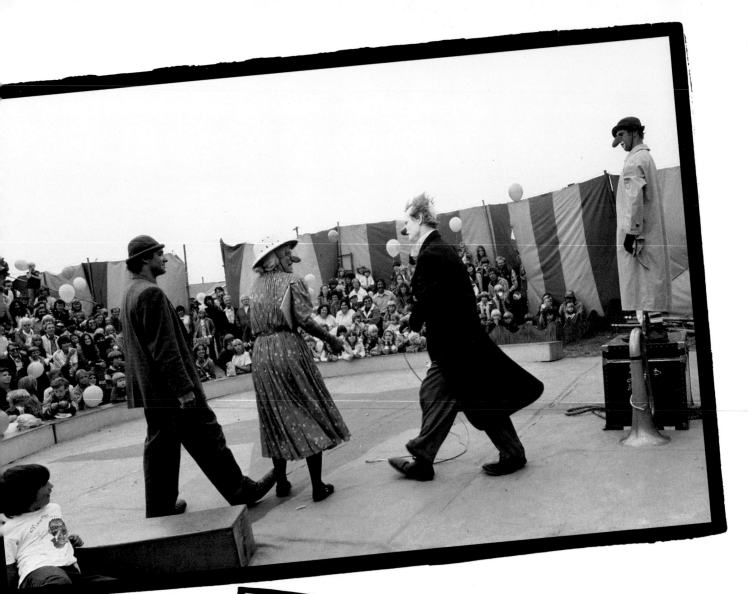

Lorenzo Pickle,
Ms. Wombat, Willy the
Clown, Mr. Sniff

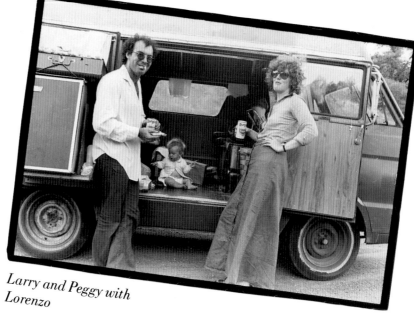

Larry and Peggy with
Lorenzo

136

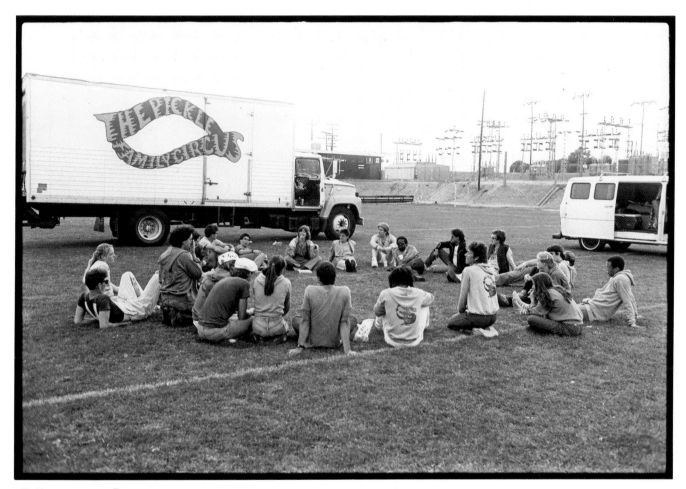

Talking it over: Post-show discussions in Stockton, California

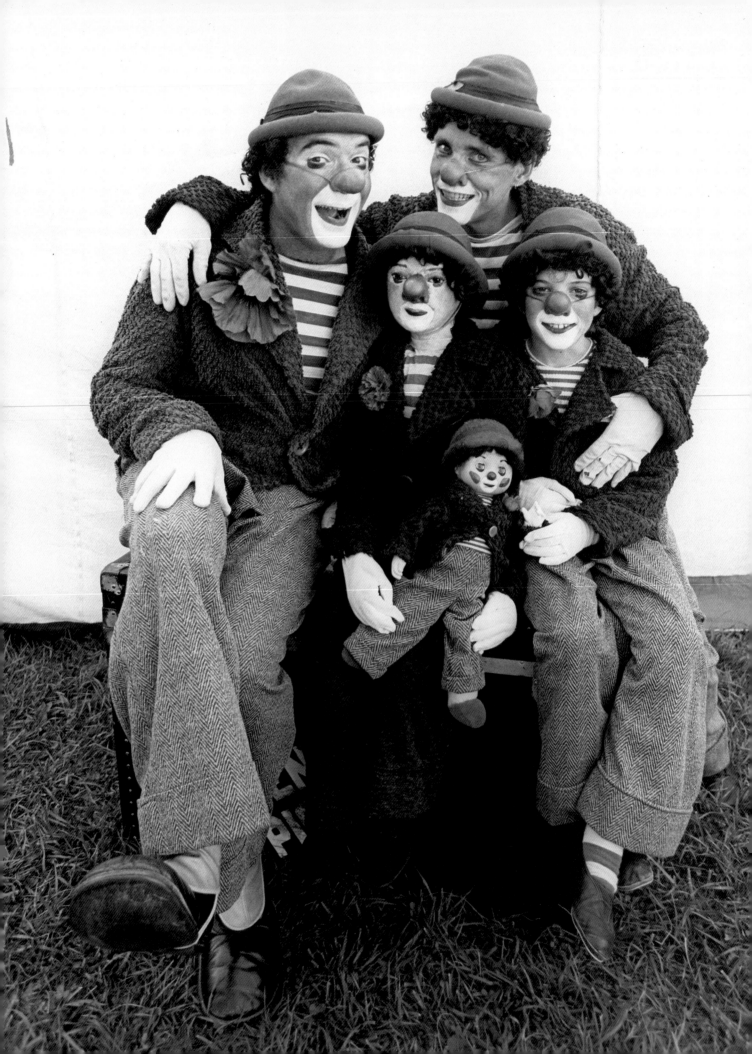

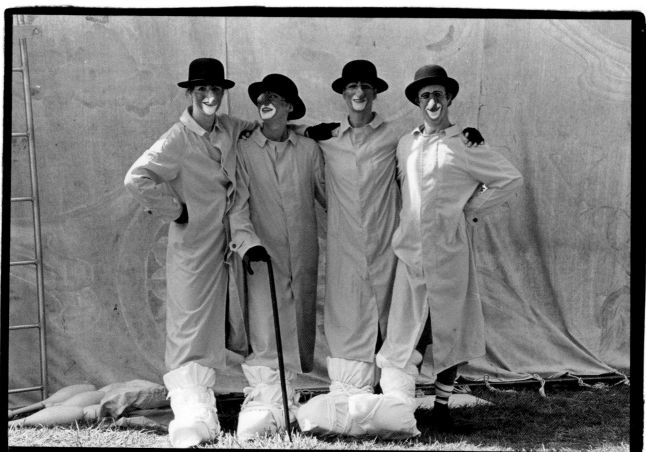

*Peggy Snider, Terry
Lorant, Wendy
Parkman, Geoff Hoyle*

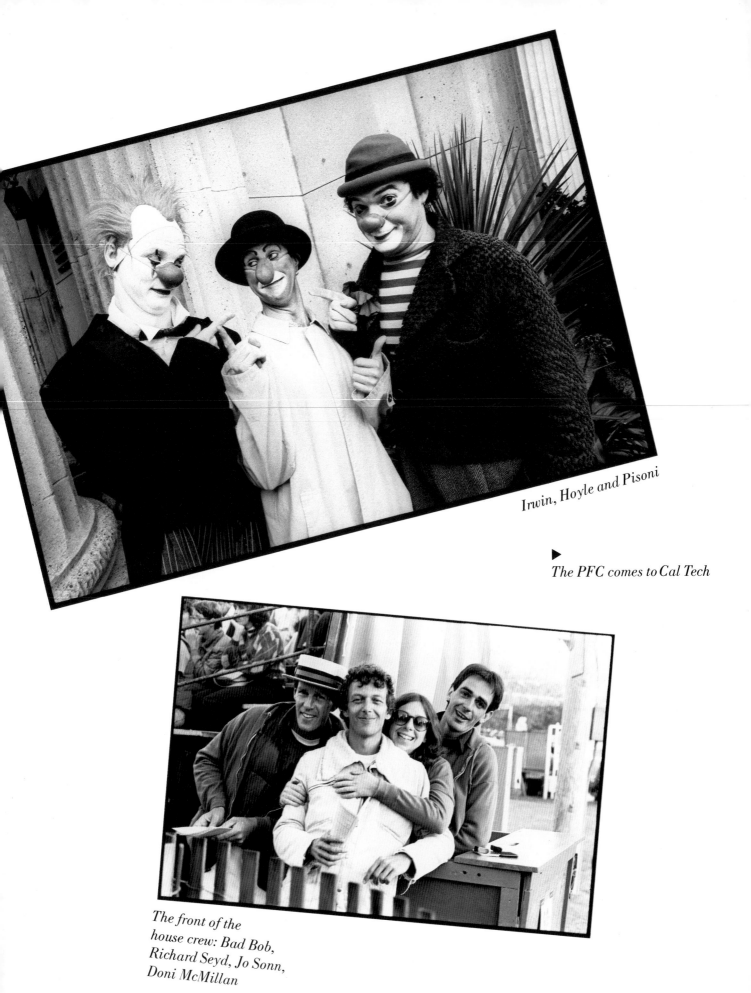

Irwin, Hoyle and Pisoni

▶ *The PFC comes to Cal Tech*

*The front of the
house crew: Bad Bob,
Richard Seyd, Jo Sonn,
Doni McMillan*

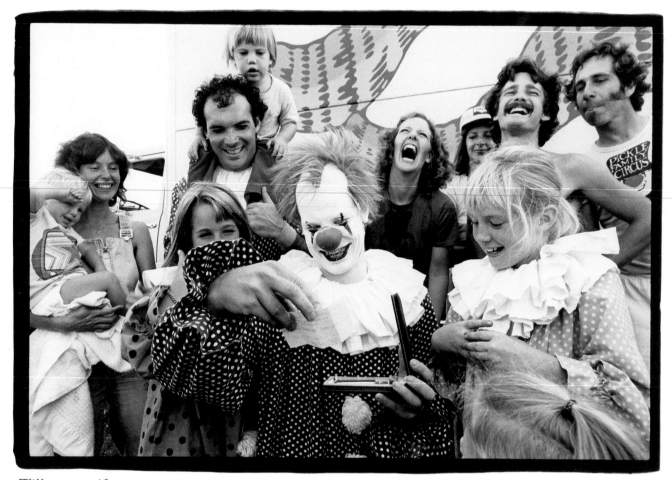

Willy gets a gift:
Jonah Hoyle, Mary
Winegarden, Melinda
Marsh, Larry Pisoni,
Lorenzo Pisoni, Bill
Irwin, Peggy Snider,
Cecil MacKinnon, Gypsy
Snider, Sando Counts,
Michael Margulis

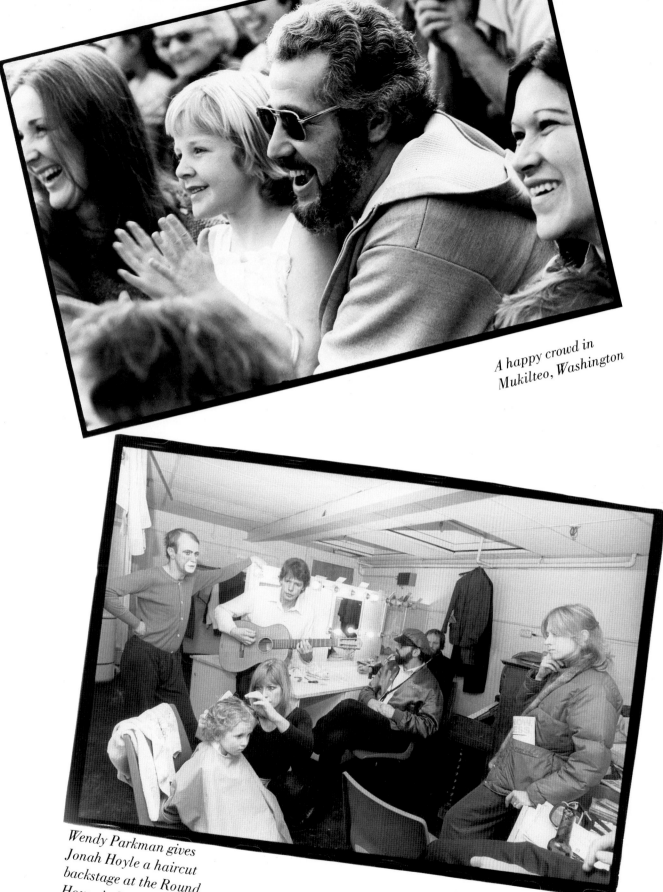

A happy crowd in Mukilteo, Washington

Wendy Parkman gives Jonah Hoyle a haircut backstage at the Round House in London; Geoff Hoyle, Mark Kennedy, Harvey Robb, Randy Craig and Susan Travers

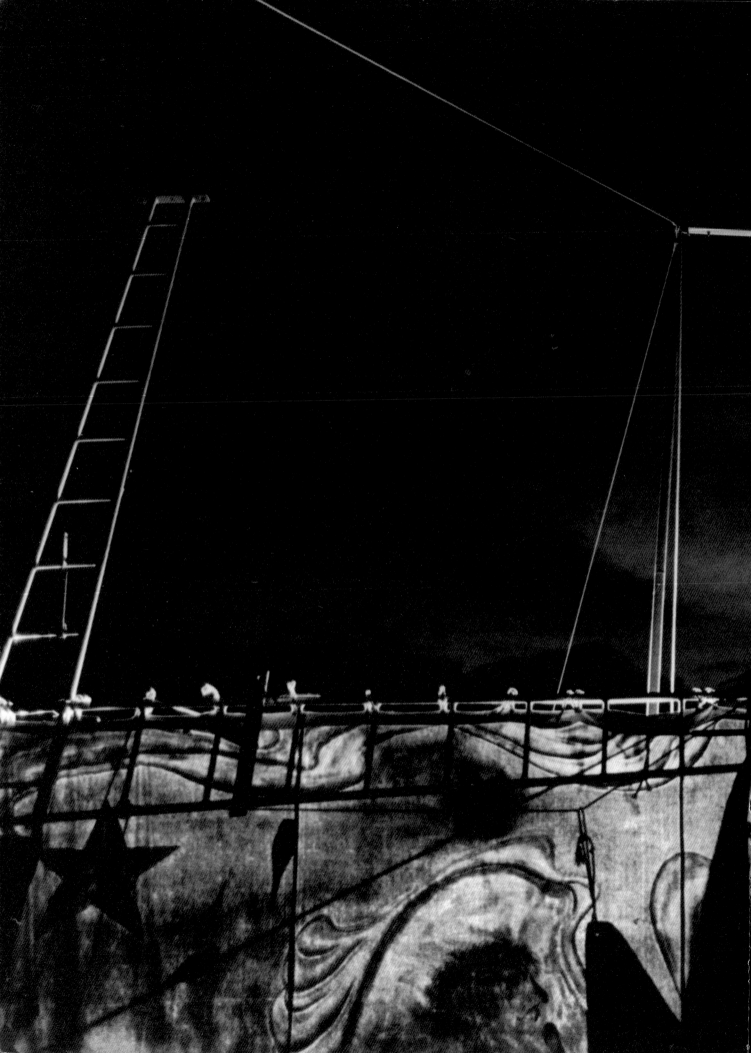

THE END

10 Years of Pickles:

Louis Aissen

Atma Anure

Bill Belasco

Al Brown

Dan Buegeleisen

Robert Burkhardt

Rainbow Canyon

Michael Christiansen

Sando Counts

Randy Craig

Charlie Degelman

Masha Dimitri

Cecilia Distefano

Sara Felder

Judy Finelli

Don Forrest

Jeffrey Gaeto

Barry Glick

Jack Golden

Merle Goldstone

Douglas Groves

Dizzy Heights

John Henry

Ken Herman

Robin Hood

Geoff Hoyle

Jonah Hoyle

Bill Irwin

John Johnson

Marc Jondall

Hannah Kahn

Mark Kennedy

Billy Kessler

Randall Kline

Jenny Klion

Jay Laverdure

Zoë Leader

Barry Levitan

Ellen Lefcowitz

Marjorie Lefcowitz

Tom Lockett

Terry Lorant

Betty Lucas

Cecil MacKinnon

Joan Mankin

Michael Margulis

Melinda Marsh

Phil Marsh

Derique McGee

Laura McKeon

Don McMillan

Edwin Medina

Peter Milio

Peter Montalbano

Michael Moore

Brenda Munnell

Jim Murdock

John Neuman

Judy Nemzoff

Michael Nolan

Kimi Okada

Kerry Ohta

Michael Ohta

Sharon Ostreicher

Wendy Parkman

Mart Pearson

Caro Pemberton

Rebecca Perez

Nic Phelps

Larry Pisoni

Lorenzo Pisoni

Dana Price

Tom Ralston

Rori Reber

Harvey Robb

Trevor Rogers

Vola Rubin

Johnny Ryan

Juan Sanchez

Nick Saumé

Nina Sazer

Sky Sela

Gypsy Snider

Peggy Snider

Peter Snider

Andrea Snow

Jo Sonn

Dianna Strauss

Benny Teo

Keith Terry

Domenica Todaro

David Topham

Susan Travers

Carlos Uribe

Jean-Paul Valjean

Glenn Weller

Jeff Weller

Kelly Weller

Shannon Weller

Tash Wesp

Alan Willey

Richard Willey

For all of the short bursts
of inspiration, three cheers
for the kids!!!

The Extended Family
(With many thanks for all
the help and encouragement
along the way.)

Stella Rose Adelman
Damon Anderson
Pablo Belasco
Abby Louisa Bradbury
Zoë Ida Bradbury
Rachel Carroll
Shana Carroll
Elo Comfort
Zander Comfort
Ian Dundas Travers Craig
Nicky Cronan
Daniel Winegarden Hoyle
Kailey Winegarden Hoyle
Miles Kennedy
Sam Sutton Kline
Alex Madero
Justine Madero
Jack MacKinnon Marsh
Lily Elena Marsh
Marin Montalbano
McLean Francis Nolan
Rosy Lowrey Nolan
Chase Lee Norvich
Justine Ohta
Marley Shepard Ohta
Toshi Shepard Ohta
Jesse Margulis Olsen
Ursula Pemberton
Molly Sierra Parkman Rogers
Olivia Parkman Rogers
Joshua Sazer
Natalia Sazer
Amelia Lloyd Terry
Alegra Joy Finelli Thomsen
Cyrus Valjean
Leanne Watson

Don Adams
Al Adato
Larry Adelman
Yasha & Carrie Aginsky
Joe & Joanne Bellan
Joe Bjorkland
Bill Bradbury
Alice Brown
Roger Brownlow
Genny Buehler
Kathy Burkhardt
Laurie Cohen
Sunny & Dana Comfort
Bill Cook
Jack Davis
Martha Diepenbrock
Ben Digby
The Farm
Gordon Fels
Sue Fox
Arlene Goldbard
Allen & Jane Gross
Ralph Gutlohn
Maureen Hammond
Leonard Harper
Betsy Harrison
Darryl Henriques
Thelma Holt
Val Hooven
Marlow Hotchkiss
Liz & Ace Irvin
Ray Jason
Maxine Karell
Kassimir Krastev
Kristavo
Ann Kyle
Roz & Tony Leader
Jeffrey Lindemann
Dawn Maskill
Jim Mayer
Nini McCone
Karen McCormick

Jenefer Merrill
John Milano
Nickie Miller
Ben Moore
Katie Nelson
Buzz Norvich
ODC-SF
Allen & Peggy Ohta
Laurie Olsen
Christina Orth
Noel Parenti
Chris Parkman
Sparkie Parkman
Les Plack
Sabra Redfern
John Rogers
Irene Rosen
Paul Rosenblum
SF Mime Troupe
Richard Saunders
Audrey & Bob Seale
Richard Seyd
Alison Shepard
Sandy & Roger Simon
Leni Sloan
Mark Smith
Marc & Mari Snyder
Marcia Sollek
John Stokes
Betsy Strausberg
Gary Thomsen
Maynard Thornton
Harvey Varga
Pat Weller
Jack Wickert
Jane & Willie Williamson
Mary Winegarden
Sigrid Wurschmidt
Benji Young
Bill Young

A partial list of sponsors:

Bananas Childcare Information and Referral
Golden Gate National Recreation Area
San Francisco Council of Parent Participation
 Nursery Schools
Children's Center of Stanford
Trout Gulch School
Ukiah Valley Child Development Center
Motherlode Women's Crisis Center
Just Desserts
Equinox School
Arcata Co-op
Bend Metro Parks & Recreation Department
St. Marks Cathedral
Potrero Hill Neighborhood House
Parkview Homes
Port Townsend
Rosehill Community Center
Coast Fork Learning Center
Sierra Curtis Neighborhood Association
Durango Fine Arts Council
Arvada Center for the Arts & Humanities
Colorado Springs Fine Arts Center
City of Greeley
University of North Colorado
Fire Mountain School
Cascade Valley Waldorf School
Children's House
Bandon Child Care Council
Gold Beach Child Development Center
Project Care
Synergy School
Sylvan School District
San Jose Explorer Pre-School
Los Gatos Parent Nursery
Summerfield School
Youth Homes
Old Mill School
Redwood Coast Seniors, Inc.
Central Labor Council of Santa Clara County
Central Coast Children's Theatre
El Camino College
Cal State Bakersfield

Community Theatre Foundation, Inc.
Community Action
Jefferson County Hospital Auxiliary
Advocates for Retarded Citizens
Seattle Food Bank
Arcosanti, Arizona
Scottsdale Performing Arts Center
City of Claremont, Human Services Division
Allied Arts Council
Levi Strauss
C.S.U. Sacramento
San Jose Performing Arts Center
Madera County Arts Council
Fresno City College
Parent's Place
Bay Area Peace Network
Friends of the San Juan Library
North Bend Chamber of Commerce
The Looking Glass
Davisville Town Fair
The Apple Project
Burroughs Corporation
Lobero Theatre Foundation
Malibu Community Center
Strawberry Recreation Center
Escondido Village
La Verne College
Alternative Schools of Jackson
 & Josephine Counties
Arthritis Foundation
Cal State Fullerton
South El Monte Park & Recreation
Fairfax/San Anselmo
 Child Development Center
Council for Exceptional Children
Chabot College
Rural Community Childcare Center
King County Association of Retarded Citizens
California Institute of Technology
Laurelwood School
Friends of the River
Rainbow Childcare Council

Sonoma State Hospital
Fort Mason Foundation
Harebrain Enterprises
Skillsbank
Willits Senior Center
North Tahoe Fine Arts Council
North Lake Tahoe Chamber of Commerce
Tahoe City Park & Recreation
Laguna Beach Educational Foundation
Santa Cruz County Fair
Sunset Magazine
Head Start Pre-School
Oregon Fair Share
Camellia City Senior Center
San Juan Pre-School
Ventura County Childcare Resource &
 Referral Center
U.C. Arts & Lectures
Los Angeles Street Scene
Children's Theatre of Nevada City
Nevada County Community Services Council
Beginnings School
Southern Humboldt Working Together
WOW Hall
Ketchikan Arts Council
Juneau Arts Council
Alaska State Fair
Wien Air Alaska
C.H.A.I.N.
Mid-Peninsula Conversion Project
U.N. Association
Santa Cruz County Children's Commission
Sacramento Single-Person's Self-Help Group
San Francisco Arts Commission
Greenhouse School
Whitebird Clinic
L.A.R.C.
Seattle Arts Commission - Bumbershoot
 Festival
Cherry Valley School
East Bay Council of Parent Participation
 Nursery Schools

A Central Place
Westwood Open Classroom
Littleton, Colorado
United Way
Waldorf Association of Portland
Golden Gate National Recreation Area
Fairfield Soroptomists

*The Pickle Family Circus
would like to thank those
foundations, corporations,
and government agencies
that have provided funding
and subsidy to our project
over the years:*

National Endowment for the Arts
California Arts Council
San Francisco Hotel Tax Fund
Comprehensive Employment & Training
 Act/Mayor's Office of Employment
 & Training, San Francisco
San Francisco Foundation
William and Flora Hewlett Foundation
Mary A. Crocker Trust
Wallace Alexander Gerbode Foundation
L. J. and Mary C. Skaggs Foundation
Zellerbach Family Fund
Walter and Elise Haas Fund
Evelyn and Walter Haas Jr. Fund
Bothin Helping Fund
Mortimer Fleishhacker Foundation
Louise M. Davies Foundation
Western States Arts Foundation
Wells Fargo Foundation
McKesson Foundation
Just Desserts
U. S. Leasing
Levi Strauss Foundation
Chevron U. S. A.
Atlantic Richfield Foundation
Wien Air Alaska
Pacific Gas & Electric Co.
Pacific Telephone
Bank America Foundation